Principles
of
Three-Dimensional Design

Objects, Space, and Meaning

Stephen Luecking

Prentice
Hall

Upper Saddle River, New Jersey 07458

Library of Congress Cataloging-in-Publication Data

Luecking, Stephen
 Principles of three-dimensional design: objects, space and meaning / Stephen Luecking.
 p. cm.
 Includes index.
 ISBN 0–13–095975–8
 1. Design. 2.Form (Aesthetics). I. Title

 NK1510.L77 2002 2001052378
 745.4—dc21

Publisher: Bud Therien
Editorial Assistant: Wendy Yurash
Production Editor: Jean Lapidus
Manager, Production/Formatting & Art : Guy Ruggiero
Formatter: Rosemary Ross
Prepress & Manufacturing Buyer: Sherry Lewis
Artist: Annette Murphy
Photo Permission Coordinator: Nancy Seise
Cover Design: Bruce Kenselaar
Cover Art: Jerry Peart, **Splash,** 1986.
Courtesy of Jerry Peart.

This book was set in 10.5/12.5 Century Schoolbook by HSS in-house formatting and production services group, Pearson Education, and was printed and bound by Von Hoffmann Press, Inc. The cover was printed by The Lehigh Press, Inc.

© 2002 by Pearson Education, Inc.
Upper Saddle River, New Jersey 07458

Printed in the United States of America
10 9 8 7 6 5 4 3 2 1

ISBN 0-13-095975-8

Prentice-Hall International (UK) Limited, *London*
Prentice-Hall of Australia Pty. Limited, *Sydney*
Prentice-Hall Canada Inc., *Toronto*
Prentice-Hall Hispanoamericana, S.A., *Mexico*
Prentice-Hall of India Private Limited, *New Delhi*
Prentice-Hall of Japan, Inc., *Tokyo*
Pearson Education Asia Pte. Ltd., *Singapore*
Editora Prentice-Hall do Brasil, Ltda., *Rio de Janeiro*

Contents

Preface

The disciplines of three-dimensional design are as varied as the objects that share our world. Between the pure expression of sculpture and the rigorous utility of engineering, between the nanotechnologist and the urban planner, are myriad journeys an author could navigate. This text veers toward the expressive principles of the sculptor, but broaches the logistics of the engineer when needed. Its underlying goal is to provide a practical and theoretical understanding of how the objects and the spaces they occupy shape the physical and perceptual nature of our reality.

We play out our days in an environment awhirl with objects. Rising in the morning we crawl from between sheets and rise from the bed while listening for the weather on the radio. On a side table may rest the reading glasses, book, and lamp from the night before. We start to don the day's clothing and address the shower, commode, washbasin, faucets, mirror, toothbrush, razor, make-up, and bottles, tubes, and jars of lotions and potions. This is just in the first few minutes of the day!

Without these objects we would literally find ourselves naked in the wilderness. There, our first impulse would be to seek clothing, food, and shelter, and to fashion the tools needed to obtain these. We would, of necessity, become three-dimensional designers.

Despite—or perhaps because of—our largely unconscious interaction with an object-ridden environment, objects shape our ideas and perceptions as much as the thoughts that we learn and expound. In his book "Man the Toolmaker," Kenneth Oakley suggests equivalence between objects and ideas in his definition of culture as "the communication of ideas and the manufacture of tools." A particular culture, by this definition, is a unique composite of its ideas and tools and of the systems by which they are propagated.

One reason that this definition works is that, often as not, ideas and things are inseparable. Objects arise from ideas and translate these into actuality. Ideas in turn emerge from relationships observed within and between objects.

The first chapters of this text look within objects for ideas. Chapters 1 through 9 examine the forms and their interrelationships that constitute objects and how these arrangements of forms aid the expressive and practical roles of the objects. Such elements of form as line, plane, surface, mass, material, and structure are examined in individual chapters. The other three chapters of problem solving, form in space, and organization address more general aspects of the interrelationship of form. In sum, these chapters offer the basis for a beginning course in three-dimensional design.

The last four chapters step outside of the objects and look at the nature of objects in time, in their environment, in virtual space, and in the

meanings they proffer. All of these have a profound effect on the role and, therefore, the design of objects. These chapters could augment a beginning course or underpin an advanced course in three-dimensional design.

The entire text is laced with references and illustrations to a variety of cultural groups. At first this was intended to round out the student's understanding of the principles covered. As the text progressed, it evolved into simply the best way to teach how form and its making intersect with the finest ideas of human thought. By seeking out these images the author personally gained renewed fascination with objects and spaces and the meanings imparted by their makers.

ACKNOWLEDGMENTS

The author wishes to thank Jalissa Bauman for her tenacious research style and gracious communication skills, and Margaret Lanterman for her patient expertise on the subject of introducing students to the world of form and its implications.

The publisher wishes to thank the following reviewers for their helpful suggestions:

Patrick James Shuck of St. Louis Community College, Meramec Campus; Pamela B. Lowrie of the College of DuPage; Paula Winokur of Beaver College; and Phil Vander Weg of Western Michigan University.

CHAPTER *1*

Problem Solving

DESIGN AND FORM

Three-dimensional designers generate physical objects to fulfill the perceived needs of a culture. These needs may be *utilitarian,* intended for the purpose of performing physical tasks, or they may be *expressive,* intended to communicate personal, cultural, and aesthetic experiences. Most often, cultural needs are complex blends of both utilitarian and expressive purposes.

No matter what the designers' differing goals, the process by which they are achieved remains essentially the same.

THE DESIGN PROCESS

The design process is a method of unearthing appropriate solutions to cultural needs. It is an approach to problem solving that is more or less consistent throughout the many fields that employ the skills of the three-dimensional designer. An international design firm might invest thousands of man-hours into the process, while the sculptor in a backyard studio may dedicate comparatively few hours to the process. In both cases, though, the same six basic steps, covered in this chapter, are followed.

Step 1: Identify the Problem

Recognize and define it. First ask, "Is there a problem? Does the solution already exist? Does it need to be solved? What exactly is the problem?"

Next establish the needs, criteria, requirements, and other limitations that set the boundaries or *parameters* of the problem. Parameters define a problem, setting out those criteria that must be dealt with in solving the problem. Parameters also exclude criteria that are superfluous to the problem's solution and should be ignored.

Step 2: Generate Ideas

This is the most creative step. There are a number of conceptual methods that creative designers use to elicit ideas:

- *Brainstorming* is batting around ideas in a group, sharing and developing ideas by using two or more heads. In brainstorming one member of the group picks up on an idea after it has been exhausted by another member and takes it to another stage.

- *Mental inventory* is a private search of one's own mind and memory for ideas. Creativity researchers have discovered that alternating such periods of private idea generation with the group idea development of brainstorming is more productive than the two methods alone.

- *Research* is investigating the documentation of past approaches to a problem. Research uncovers promising *archetypes,* i.e. major categories of form that have in the past been exploited by

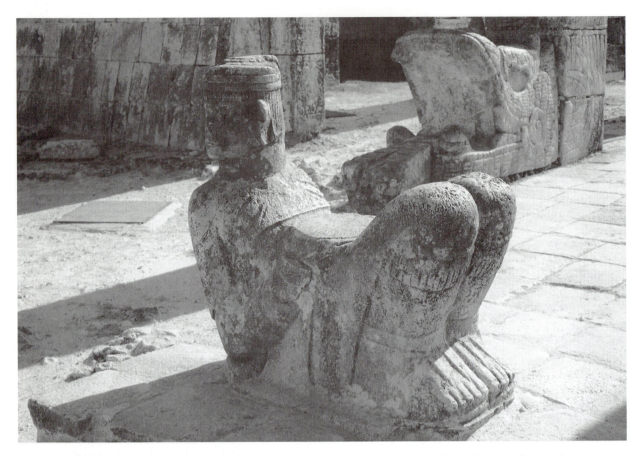

FIGURE 1–1 Mayan, Pre-Columbian Mexico, Chichen Itza, Temple of Kukulkan, ***Chac Mool,*** ca. 1100.
Source: Photo courtesy of Margaret Lanterman.

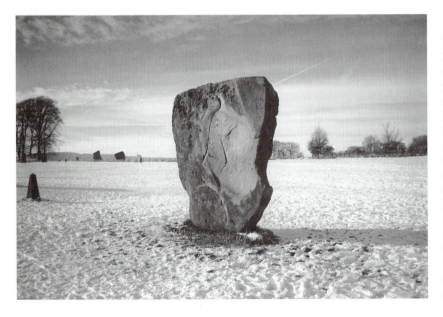

FIGURE 1–2 Pre-historic British Isles, ***Megalithic Menhir,*** ca. 2000 B.C.E. Artists may draw their ideas from a variety of unexpectedly diverse sources and synthesize these into their own unique expression. Often artists will turn to history, other cultures, and nature to seek out archtypes on which to pattern their ideas. In one series of reclining abstract figures, English sculptor Henry Moore used the classic Mayan image of the rain god Chac Mool as an *archetype.* From his own countryside ancient standing stones inspired the forthright power of his carvings.
Source: Photo courtesy of the author.

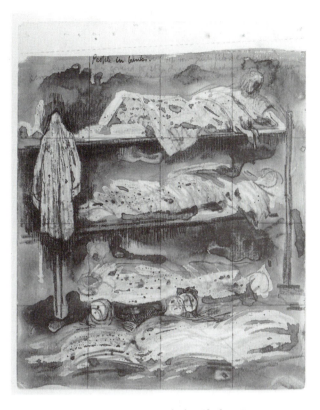

FIGURE 1–3 Henry Moore, study for ***Shelter Scene: Bunks and Shelterers,*** 1941.

Source: Henry Moore (b. 1898), Second Shelter Sketchbook, 1941. Study for "Shelter Scene: Bunks and Shelters" (page 33). Pencil, white wax crayon, green crimson, yellow, orange, brown, black crayons over wax crayons. Indian ink wash, pen and Indian ink. 204 x 165 mm (8 x 6½ in.). Reproduced with permission of the Henry Moore Foundation.(HMF 1658)

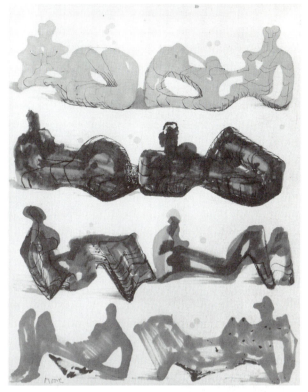

FIGURE 1–4 ***Eight Reclining Figures,*** 1962. For artists, research may be constant and very personal. During air raids in World War II, Moore continued to sketch his fellow refuge-seekers in bomb shelters. A later set of drawings, created to explore ideas for abstractions, manifests the influence both of the shelter drawings and the image of *Chac Mool* (see Figure 1–1).

Source: Reproduced with permission of the Henry Moore Foundation. (HMF 3083)

nature, vernacular culture, or technology to solve related problems.

- *Lateral thinking* is "sideways" thinking. It is a form of associative thinking that deliberately runs askew to the expected paths of normal thought. Lateral thinking assumes that no potential solution is too absurd to hold the germ of an unusual, but effective solution.

Sketches and Notes Record these initial ideas in the form of thumbnail sketches, sketch models, and written notations:

- *Thumbnail sketches* (or simply *thumbnails*) are small, quick drawings that function as visual notes for the designer. Thumbnails are usually the very first visual realization of an idea and dozens of thumbnails might be jotted down before the glimmer of a solution appears.

- *Sketch models* are the three-dimensional equivalent of thumbnails. The designer fashions cheap, handy materials—most often paper—into small constructions in order to initially test the viability of an idea in three-dimensional form.

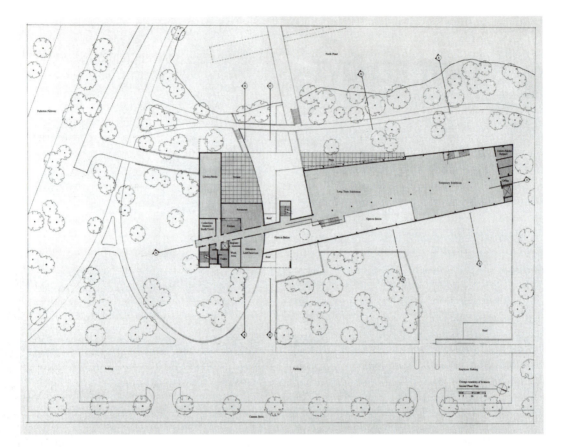

FIGURE 1–5 Ralph Johnson, Principal Designer, Perkins and Will, preliminary plan for the ***Peggy Notebeart Nature Musuem,*** 1994. Henry Moore was an individual artist, but design and architectural firms are congregations of up to hundreds of people working on a single project. The design process in both cases, however, remains remarkably similar. A sculptor's preliminary drawings and models aid in clarifying ideas for the individual artist. The same holds for an architectural team, with the exception that these initial visualizations must be communicated to a larger group. Consequently, early architectural drawings tend to be more formalized and specific. This highly schematic drawing divides the building and its site according to the *utilitarian* function of the various spaces.

Source: Reproduced by permission of Ralph Johnson, Perkins and Will. Courtesy of Perkins and Will.

- *Written notations* are "thinking aloud" onto a piece of paper. They most often accompany and complement sketches, but they can also serve to pin down an elusive line of thought before it wriggles away.

Step 3: Refine and Analyze

This is the first cycle of evaluation and criticism.

Assess the ideas against problem criteria and parameters. Then accept, reject, enlarge, or boil down the most promising solutions. Present the refined versions in more worked drawings, models, or mock-ups.

- *Drawings* Designers and artists produce two types of drawings to represent their more finished ideas. The first type, *presentation drawing,* represents an idea to the client or the viewing public and as such is more visually engaging than the second type, a *working drawing.* Working drawings are more measured and schematic because they function as

the reference from which to begin building the object.

- *Models and Mock-ups* Models are three-dimensional representations built at a smaller scale than the proposed object. The model is the stage where the designer really sees an idea take shape.

Before building a fully finished model to present to the client, most designers will build a *white model* for their own reference. White models get their name because they are usually constructed from paper and foam and are left unpainted. Most of the construction techniques presented in this text are those used in making white models.

A full-scale model is called a *mock-up.* Built of inexpensive materials, mock-ups inform the designer of the impact and effect of an object when viewed actual size in its environment.

FIGURE 1–6 White model for the ***Peggy Notebeart Nature Musuem,*** 1995. Created from cheap, easily worked sheets of foam board this early model conveys the overall appearance and expressive intent of the building's design. Strong geometric planes play off rolling earthen mounds, situated between two lagoons and dotted with mature trees. Huge glass walls enable visitors to experience natural elements of the site while viewing the nature exhibits inside.

Source: Reproduced by permission of Ralph Johnson, Perkins and Will. Courtesy of Perkins and Will.

FIGURE 1–7 Ralph Johnson, ink rendering for the ***Peggy Notebeart Nature Musuem,*** 1997. In a major international firm like Perkins and Will the various design tasks such as executing plan drawings or constructing models are delegated throughout the team. Like the director of a play, the principal designer retains control over the overall design conception. In this case, Johnson chose to execute the *presentation drawings* himself. His high-contrast, graphic style echoes the dynamic geometry and clear planes of his building design. This drawing has been carefully composed to express Johnson's idea of uniting exterior and interior environments. Note his inclusion of wooded and urban forms, the lines of the building, and cutaway views to an inside display.
Source: Reproduced by permission of Ralph Johnson, Perkins and Will. Courtesy of Perkins and Will.

FIGURE 1–8 Finished wooden model for the ***Peggy Notebeart Nature Musuem,*** 1997. A design can change significantly as it goes through various reviews and refinements. A comparison between the earlier white model above and the final presentation model reveals two major design changes. Due to budget constraints large sections of glass wall overlooking a park lagoon were eliminated. To compensate, the design team changed the angle of the roof to direct the roofline toward the inner court and concentrated the glass planes around this central space.
Source: Reproduced by permission of Ralph Johnson, Perkins and Will. Courtesy of Perkins and Will.

FIGURE 1–9 (opposite page, top) Henry Moore, ***Two Piece Reclining Figure, Maquette No. 3,*** 1961. Bronze, 8 inches long.
Source: Reproduced with permission of the Henry Moore Foundation. (LH 475)

FIGURE 1–10 (opposite page, bottom) ***Two Piece Reclining Figure No. 5,*** 1963–64. Bronze, L. 147 in. The need, which the sculptor seeks to resolve, is a personal expression of his or her own definition. The design task is to assure the successful realization of this expression. As he approached the finished stages, Moore fabricated several maquettes and selected the most appropriate to his conception. Since the final work is cast in bronze, Moore created a full-size pattern in clay, which also served as a *mock-up.* Note the many subtle differences between the maquette and the final sculpture. At this point Moore effected final revisions in detail, form, and proportion that the full-scale realization required.
Source: Reproduced with permission of the Henry Moore Foundation. (LH 517)

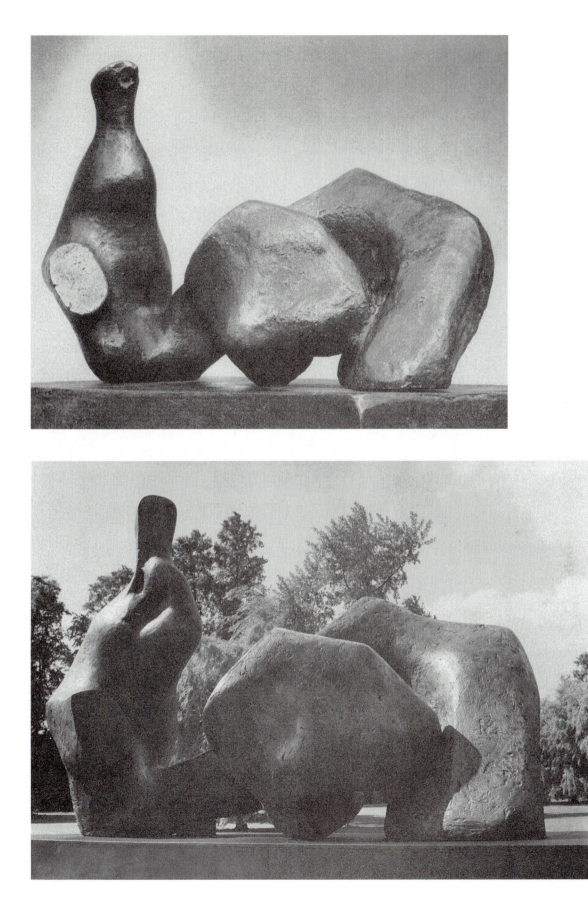

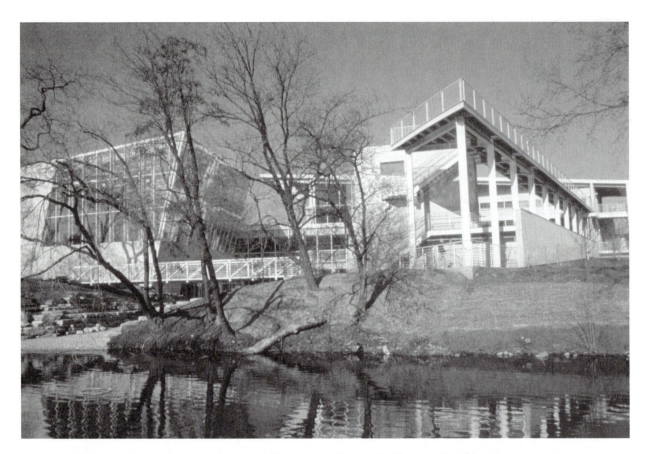

FIGURE 1–11 Ralph Johnson, Principal Designer, Perkins and Will, ***Peggy Notebeart Nature Musuem,*** 1999. The completed building demonstrates the effectiveness of the designers' strategy of grouping the transparent glass walls at the building's central court. This strategy couples both the transparency and reflective value of the glass to merge the structure with nature. At the same time, the dynamic conjunction of planes asserts the building's sculptural vision.
Source: Reproduced by permission of Ralph Johnson, Perkins and Will. Courtesy of Perkins and Will.

Step 4: Create the Prototype

The *prototype* is a working, fully functional version of the object created in finished materials from the most viable proposal.

Step 5: Decide

This is the final cycle of evaluation and criticism: (1) Accept and possibly "fine tune" the object after evaluating, *or* (2) reject the prototype and begin again.

Step 6: Implement

For sculptors or one-of-a-kind craftpersons this is a straightforward step. Their decision to sell or exhibit their prototypes is the implementation, since the prototypes are the final solutions to their problems.

For product designers the concerns of production and marketing, key parameters of their original problems, now come into play.

CREATIVITY

Creativity is a special form of problem solving that requires *associative* and *integrative* thinking. *Associative thinking* leaps to and from images, places, actions, ideas, and the like by means of connections that rely on any of a myriad of attributes or on the past experiences of the leaping

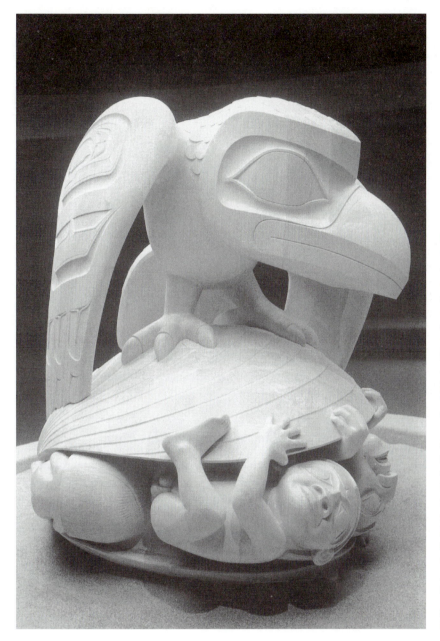

FIGURE 1–12 Bill Reed, *Raven and the First Man, No. 1,* 1978. A Haida artist of Canada, Reed retained his native sculpture tradition while creating universal and contemporary messages. In this depiction of an ancient creation myth he *synthesized* many aspects of creativity: the embryo, the birthing child, and the adults creeping from their clamshell prison. Some of the adults are eager to leave, but others are reluctant: not everyone embraces creative change.

Finally, in a nod to the wisdom of the ancients, it is Raven, the trickster god, who releases creation. The clamshell of Haida myth is a close kin to Pandora's box of Greek mythology, another ancient metaphor of creativity. Like most human capabilities, creativity is a mixed blessing. It can unleash both the best and worst of human actions.

Source: From the Walter and Marianne Koerner Collection. Height: 10 cm, Width: 180cm. Photography: W. McLennan. Courtesy of the University of British Columbia Museum of Anthropology.

mind. The connections need by no means be logical. More often than not, they are sensory.

Integrative thought synthesizes the entities reached by association into new combinations that address the problem at hand. These are the output of creativity. If the output survives the rigors of *critical analysis*, then the creative act has been successful.

CHAPTER 2

Form in Space

DESIGN AND FORM

Form is the imposition of organization, structure, and purpose onto matter. *Design* weds expression and logic, consolidates imagination and reality, through form.

Elements of Form

The basic elements of form are point, line, plane, volume, color, and texture. These fundamental elements combine, interact, and unite under the control of a designer into the myriad visual and spatial forms that make up the built world.

Every form requires a conceptual component and a material component that are integrated to produce that form's unique character. The conceptual component imparts shape to the form and the material component adds richness, color, and texture.

Point, line, plane, and volume are the *conceptual* elements of form. These elements have no actual physical substance. They are ideas, abstract tools the human mind uses to analyze, define, and structure space.

A true point, for example, denotes only position, but has no dimension and therefore no physical existence. The dot left by a pencil's tip on a sheet of paper, though read as a point, pos-

sesses minimal length, width, and even thickness. This dot is a physical substance that manifests position.

Three-dimensional Form

In three-dimensions form includes *actual* plane and volume, which in two dimensions exists only through *illusion*. Three-dimensional form tackles the exigencies of real existence and must be viable in physical space.

The designer's imagination is tempered, controlled, and focused by physical laws. The purely visual concerns of the two-dimensional designer are significantly supplanted by the more literal concerns of material and structure.

Space

A realm of openness we call space is necessary in order to manipulate material into form. This may seem obvious, but the serious consideration of space and its implications is essential to good design.

Without form, space is a featureless void, but without space, form tends to become merely constrictive chunks of matter. Space activates and defines form, while form activates and defines space.

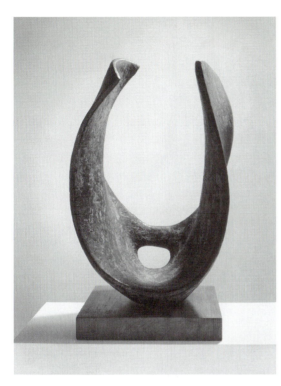

FIGURE 2–1 Barbara Hepworth, ***Curved Form (Travalgan),*** 1956. Bronze.

Source: Courtesy of Tate Gallery, London/Art Resource, NY.

FIGURE 2–2 Charles and Ray Eames, ***Soft Pod Group,*** 1987.

Source: Courtesy of Herman Miller, Inc.

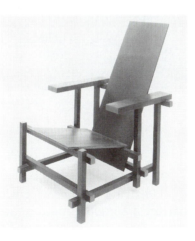

FIGURE 2–3 Gerrit Rietveld, ***Rietveld (red/blue) Chair, 1917.***

Source: Reproduced with permission of Centraal Museum, Utrecht.

FIGURE 2–4 Jean Gorin, ***Architectural Plastic in Space,*** 1929. Each pair of objects contains one pure sculpture and one usable chair. Our natural inclination is to group the objects according to their *form* rather than their respective uses: to classify the objects into curved and rectilinear sets, rather than sets of chairs and sculptures. Form lays the foundation for our most primary response to objects.

Source: Reproduced with permission of Centraal Museum, Utrecht. Courtesy of Prof. Dr. Serge Lemoine.

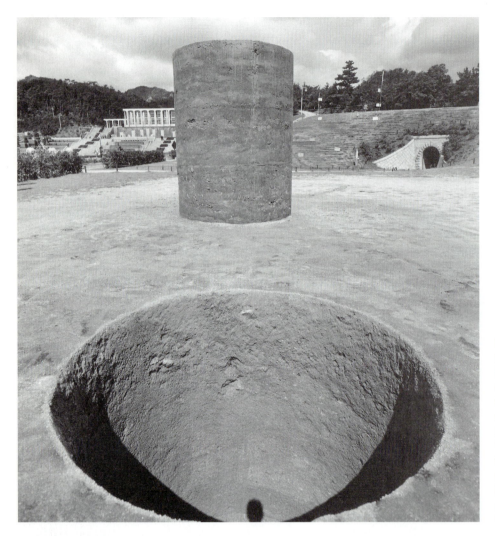

FIGURE 2–5 Nobuo Sekine, ***Phase—Mother Earth,*** 1968. Sekine's earth sculpture consists of two huge and complementary forms, one *positive* and one *negative.* Vision compels us mentally to insert the massive displaced cylinder back into the earth.
Source: Courtesy of Mr. Osamu Murai.

SPATIAL PRINCIPLES

Positive/Negative

The fact that empty space can possess form just as does a material means that a circle can be formed as either a disc or as a round hole, that a donut and its hole can both be circles. This is the spatial principle of positive/negative, one of four principles that govern how a form—like a circle—occupies space.

In addition to positive/negative there are the spatial principles of position, direction, and scale. These principles determine both the relation of the form to the space that contains it and to the other forms in composition with it.

Position

Position sets the location of an element within a compositional space and relative to other elements in that space. It governs whether, for instance, an object should be placed nearer the ceiling or the floor of a room, in the middle of a room or crammed into a corner; whether in front of or behind another object, above or below, within or without, close to or distant to that other object.

Direction

Direction, too, is relative. It measures the angle of an element within a space and toward other elements in a composition. The *primary*

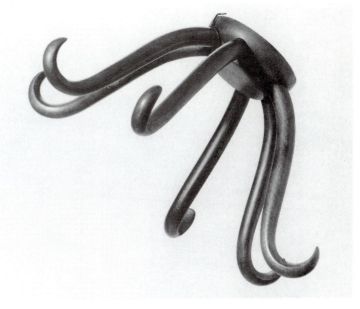

FIGURE 2–6 Marcel DuChamp, ***Hat Rack,***
1964. DuChamp often repositioned the spatial
location of everyday objects and offered them
as art. Here he has demounted a hat rack from
its original location on the wall and suspended
it just below the ceiling, out of reach and out
of use.

Source: Marcel Duchamp, American, born France,
1887–1968, "Hat Rack," wood, 1964 version of a
lost 1916 original, 24 x 44 cm. Through prior gifts of
Mr. and Mrs. Carter H. Harrison and Mr. and Mrs.
Edward Morris, 1989.54 front. Photograph © 1998.
The Art Institute of Chicago. All Rights Reserved.

orientation of a form in space is experienced with
reference to gravity. Horizontal and vertical ori-
entations conform to the constraints of gravity
and, as such, evoke a sense of stability. Diago-
nal orientations, by contrast, convey dynamism,
a sense of movement free from the constraints of
gravity.

The *secondary orientation* of a form de-
fines its direction in relation to other forms in
a composition. Two forms may be *perpendicu-
lar, skewed,* or *parallel* to one another. Perpen-
dicular and parallel forms suggest a sense of
planning, a more plotted composition than an
arrangement of skewed forms.

Scale

Scale is the size of a form as compared to
the space containing it, to another form, or to
the human body.

Since a human being is the ultimate
user/observer of most design, the size of the av-
erage human is the prime determinate of scale.
The three major categories of scale for most de-
sign—*object, human,* and *monumental*—relate
to our bodies and draw psychological connota-
tions from that relationship. Roughly, object
scale refers to designs that can be held, and
therefore controlled, in one's hand; human scale

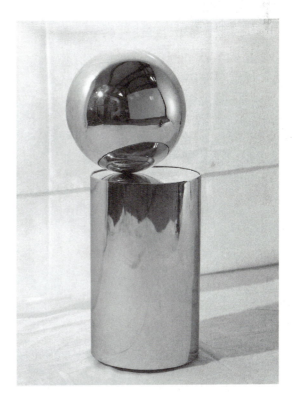

FIGURE 2–7 Pol Bury, ***Sphere on a Cylinder,*** 1969. 20″
high. Three points, the center of his polished sphere, its
point of tangency to the top of the cylinder, and the center
of the circular top, hold subtle and carefully calculated *po-
sitions* in Bury's sculpture.

Source: Courtesy of Pol Bury. © 1999 Artist Rights Society,
NY/ADAGP, Paris. Photograph courtesy of Galerie Maeght, Paris.

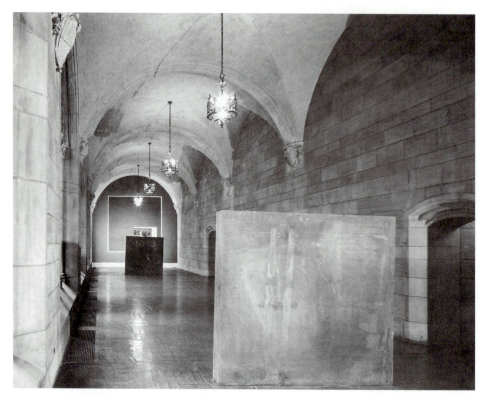

FIGURE 2–8 Richard Serra, ***Stacks,*** 1990. Two large slabs of cast steel face off from either end of a corridor at Yale University. Serra positioned the slabs at a distance and in *parallel* directions to elicit visual tension and unity across the vaulted space. Noted for exploiting the elements of his sculptures' sites, Serra sets his slabs *perpendicular* to the architectural surfaces of the gallery.

Source: Richard Serra (American, b. 1939), "Stacks." Rolled steel, 1990. Two pieces, each 93 in. H x 96 in. W x 10 in. D (236 x 244 x 25 cm). Yale University Art Gallery. Katharine Ordway Fund.

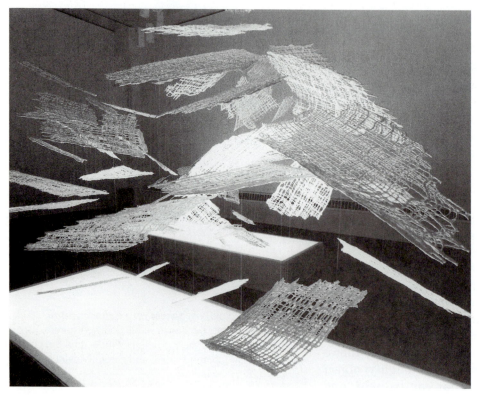

FIGURE 2–9 Marjorie Woodruff, ***Oddments.*** Ceramic artist Woodruff hung broken sheets of fragile porcelain at random, *skewed* angles to one another to project the sense of a shattered field of space.

Source: Courtesy of Marjorie Woodruff.

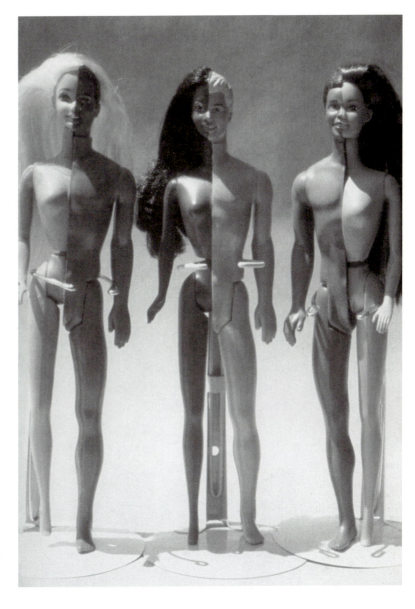

FIGURE 2–10 Robert Tavani, ***Bi–Bi.*** As *miniature* images of humans, dolls have traditionally reflected idealized microcosms of culture. For decades Barbie dolls have proffered a Lilliputian view of an impossible body and lifestyle. Tavani subverts such images by halving Afro-American and Euro-American versions of the Barbie and Ken figures and cleaving one to another. This set of figures plays with racial and sexual boundaries by re-alizing the possibilities of biracial and bi-gendered recombinations.

Source: Courtesy of Robert Tavani.

suggests designs equivalent in size to one's body; and monumental designs, by virtue of towering over their huma obsnervers, tend to dominate their immediate environment.

 Miniature scale describes a level yet small-er than the object scale, while *environmental* and *geographic* scales refer to constructions that fill the landscape or are measured in geographic units.

 The measure of the scale of one form rela-tive to another is termed *proportion.* A designer can mathematically determine proportion (see Chapter 4) or rely on intuitive judgment.

POINT OF VIEW

Gravity and the structural properties of vari-ous materials place physical constraints on the disposition of forms in space. Less apparent are the perceptual constraints that the observer brings to the experience of form and space. One

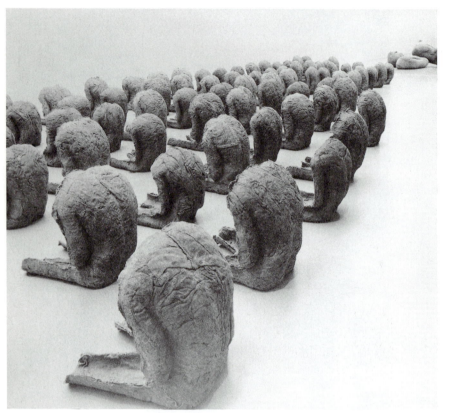

FIGURE 2–11 Magdalena Abrakanovicz, detail of **Backs,** 1976–1980.

Source: Magdalena Abrakanovicz, "Backs," 1976–1980. Burlap and resin, eighty pieces. Life size, H 61–69 cm; D 50–56 cm; W 55–66 cm. Courtesy of the artist. © Magdalena Abakanowicz/Licensed by VAGA, NY.

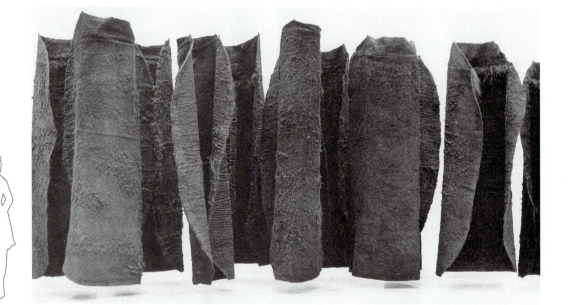

FIGURE 2–12 *Black Environment,* 1970–1978. Abrakanovicz was one of the first artists to merge fabrics and sculpture and to introduce *monumental scale* to weaving. Her hollow "Backs" are *human scale,* bowed shells drained of spirit. Her "garments," in *Black Environment,* however, are hulking shadows that overpower the viewer (see scale figure appended by author). These works, created when her native Poland grated under Soviet control, masterfully exploit scale to express the effects of a repressive society.

Source: Magdalena Abakanowicz, "Black Environment," 1970–1978. Sisal weaving, fifteen pieces. each 300 x 80 x 80 cm; Each on metal support. Exhibition at the Museum of Contemporary Art, Chicago and Chicago Cultural Center. Courtesy of the artist. © Magdalena Abakanowicz/Licensed by VAGA, NY.

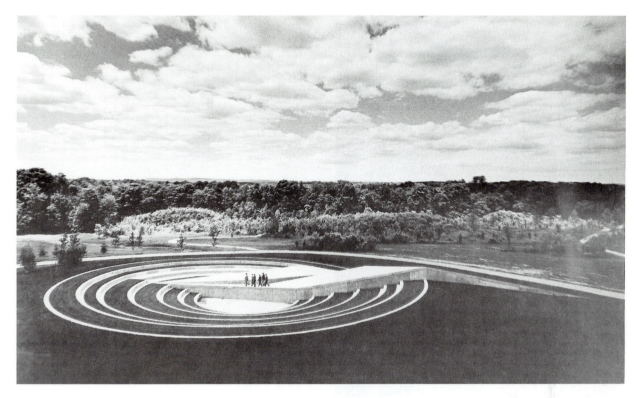

FIGURE 2–13 Beverly Pepper, *Amphisculpture,* 1974–1979. This *environmentally scaled* sculpture created for AT&T has a diameter almost equaling the length of a football field.
Source: Courtesy of the artist. © 1999 Beverly Pepper/Licensed by VAGA, NY.

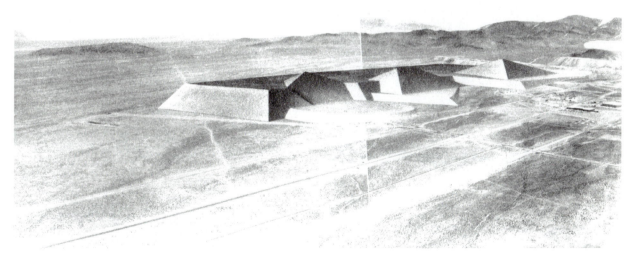

FIGURE 2–14 Michael Heizer, *Geometric Land Sculpture/Anaconda Project,* 1981. Truly gigantic sculptures often exist primarily as proposals in the form of drawings, photomontages, or digitally manipulated images. Heizer's sculpture aspired to *geographic scale.* Proposed to be a mile long and to incorporate one million tons of earth, Heizer worked for five years and completed one-third of the project before his client Anaconda Minerals was decommissioned by Atlantic Richfield, the parent corporation. The photomontage survives as a record of the sculpture.
Source: Reproduced with permission of Michael Heizer.

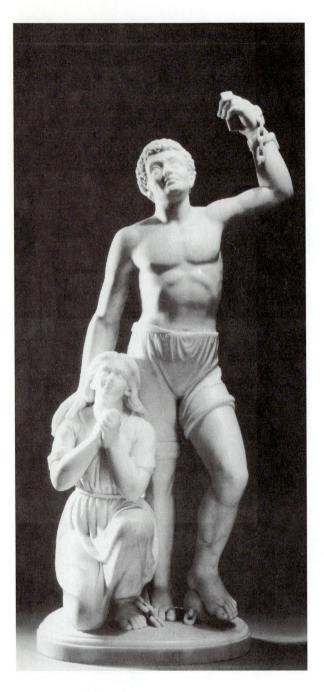

FIGURE 2–15 Edmonia Lewis, ***Forever Free,*** 1867, Marble. Lewis, the top African-American sculptor of her day, carved this marble image of emancipated slaves just after the American Civil War. Her open and dynamic arrangement of forms and the free movement of the viewer *around* the sculpture serve her theme of present and future freedom.

Source: Courtesy of The Howard University Gallery of Art, Washington, DC.

perceptual constraint is physically determined: *point of view* (p.o.v.) relies on the viewer's own physical position in space relative to the forms under view.

Frontal p.o.v. sets the viewer in front of an array of forms. Back and side views are less important and the designer accounts for this in ar-

ranging a composition. With *full-round* p.o.v., all views are important and the forms of a composition deploy in space to accommodate the observer's multiple, changing p.o.v.'s.

In such fields as architecture and environmental arts yet a third, *internal,* p.o.v. situates the viewer within the spatial composition. The

viewer physically moves and passes through the surrounding forms. The composition and the viewer share the same space.

FRAME OF REFERENCE

A second perceptual constraint is *frame of reference*. Paintings and most two-dimensional art forms dwell in the flat rectangular space of their frame. This frame is the *format,* the primary reference, against which position, direction, and scale are realized.

For a site-specific object, especially one designed for an architectural space, walls, floors, and ceilings define a sort of three-dimensional frame in which to read the object. Most three-dimensional objects, though, exist with a less

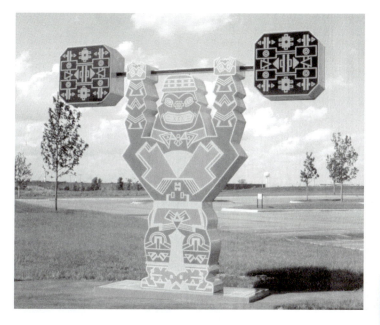

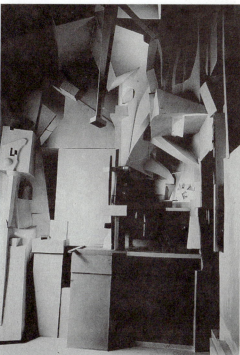

FIGURE 2–16 Karl Wirsum, ***Eddie Fist.*** Wirsum's muscle man borrows from the frontal viewpoint of painting. Indeed, the graphic shapes and strong colors filling its surface are more painting than sculpture. Both the sculpture's symmetric frontality and its heavy geometric patterning suggest a primitive religious icon recast into a contemporary pop format.
Source: Courtesy of Karl Wirsum.

FIGURE 2–17 Kurt Schwitters, ***Merzbau,*** 1933. Loosely deployed geometric forms jutted from the walls and ceilings of a room in the artist's home to create a cave-like space seen from an *internal* point of view.
Source: Courtesy of Kurt Schwitters. Archiv im Sprengel Museum, Hannover, Germany.

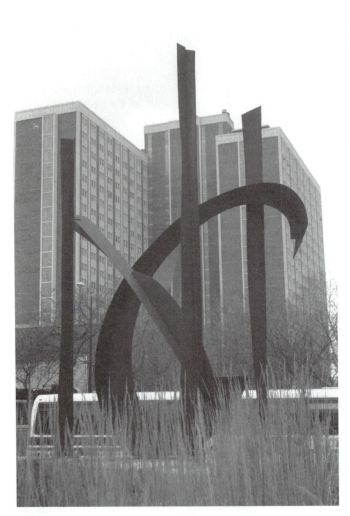

FIGURE 2–18 Herbert Ferber, ***Untitled,*** 1972. Ferber is often credited as the first contemporary artist to place abstract monumental sculpture into public architectural settings. This sculpture plays its sweeping arcs against the upright supports that *frame* it. Note how the framing elements help to define the negative spaces of the composition and how the artist's dynamic forms activate those spaces. Note, too, how the arced shapes twine around an *implied,* but unseen, axis.

Source: Photo courtesy of the author.

FIGURE 2–19 Man Ray, ***Lampshade,*** 1921. By contrast to Ferber's sculpture, Man Ray's forms curve around a very physical axis. The sculptor undid a lampshade and let it cascade around its pole. The pole became the sculpture's vertical axis and a key visual element of the composition.

Source: Man Ray (American, 1890–1976), "Lampshade." Painted (white) tin, metal rod, wing bolt, square bolt, round metal flange, screwed to round wood base. Signed and dated and inscribed on top of base: "LAMPSHADE/MAN RAY N Y 1921." 115.3 x 7.7 cm (45⅜ x 3¹/₁₆ in.) Yale University Art Gallery. Gift from the estate of Katherine S. Dreier.

FIGURE 2–20 James Rosati, ***Dialogue.*** Rosati cantilevers his massive forms just above the *ground plane.* The result is a taut tension between that plane and the masses hovering over it.

Source: James Rosati (American, b. 1912), "Dialogue." Painted Cor-ten steel (yellow) 1964–1969. Signed on base corner: "Rosati 64.69 Work executed by/Lipincott/ North Haven, Conn". 500 x 348.2 x 238 cm (16 ft., 5 in. length x 11 ft. 5 in. diameter x 7 ft. 10 in. height). Yale University Art Gallery. Seymour H. Knox, B.A. 1920, Fund.

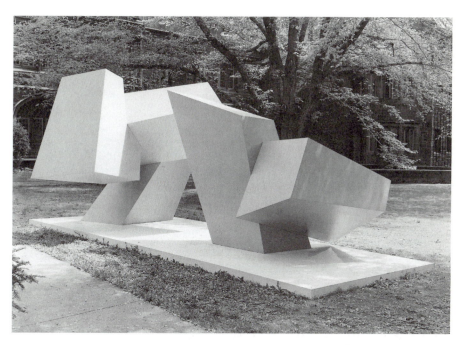

clearly demarcated frame of reference. The most common frame of reference for three-dimensional objects consists of two elements: a *vertical axis* and a *ground plane.* The vertical axis is the upright line, about which the forms of the composition deport to achieve visual and physical balance. This line may be visible or, most likely, implied within the composition. It is the vector of an object's ascendance into space. The ground plane, in its turn, forms the horizontal reference against

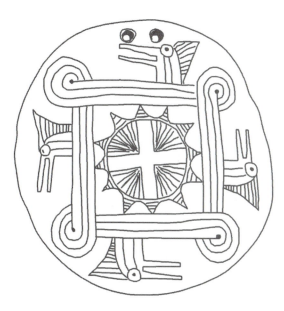

FIGURE 2–21 Mississippian culture, ***Gorget.*** This drawing of the engraving on a shell from the Pre-Columbian Gulf Coast features the heads of four birds arrayed in a variant of a *swastika,* or bent arm cross. Across time and cultures the bent arm cross has been a sacred encryption of harmony in the universe: its axes correspond correspond to the four cardinal directions and its arms bend to the clockwise rotation of the heavens. On traditional Japanese maps it marks temple sites and it graces the entryways to ancient Hindu temples. Such sacred meanings make good sense given the form of this cross, but they are difficult, if not impossible, for most of members of Western culture to now see. Recent history and the Nazi atrocities have created an emotional context that far outweighs the sacred meanings of the swastika. In most cases, though, as in the Japanese and Hindi uses of the bent cross, context enriches rather than subverts form. Context can layer added meaning or it can deepen the intrinsic meanings suggested by a form. Expression works diligently at coordinating form and its context.

Source: Temple Mound Museum., Fort Walton Beach, FL. Fort Walton Culture, Late Mississippian, Marine Shell Effigy Bowl (Pensacola Incised), 1350–1500 C.E. Ceramic, H. 7.6 cm, W. 29.2 cm. Illustration by the author after Dirk Bakker, Photographer. Photograph © 1998 The Detroit Institute of Arts.

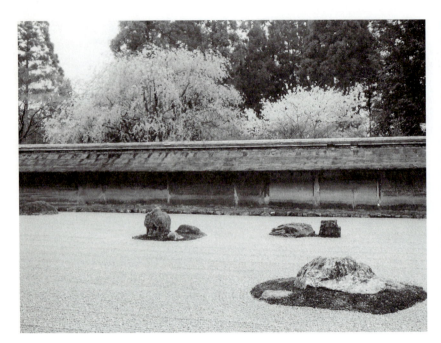

FIGURE 2–22 Japan, ***Zen Garden of Ryoan-ji Temple*** (Akiharu Iwata) 1450. In Asian Pacific cultures, the idea that form exists primarily to define space runs counter to the traditional European perception that space exists to hold form. In these cultures, it is the experience of the intervals of space between forms that is the basis for expression. For this reason the dry garden of the Zen monastery of Ryoan-ji contains only a few boulders to punctuate its landscape. The Japanese use the term *ma* to denote that these intervals are not empty, but filled with space.

Source: Courtesy of Ryoan-ji Temple, Kyoto City. Reproduced with permission.

which compositional elements are viewed. A frequent impediment to dynamic composition is an over reliance on the ground plane for the sake of stability. Such compositions often seem to have acquiesced to gravity, to become bottom heavy, weighted down and passive.

FORM AND CONTEXT

A space is the context, the perceptual arena, in which the potential meaning of forms is played out. Whatever intrinsic appeal forms might carry, the space in which they are experienced will subtly condition, even radically change, their impact.

The most immediate context is the physical frame of reference in which the forms are presented. Less immediate, but no less profound, is the *cultural* import carried by the viewing space. Be it museum, church, courthouse, sports arena, one's home, a corporate office, or some other place, specific spaces predispose specific sets of expectations and behaviors in their users.

The cultural contexts affecting the viewer are often less apparent than specific social sites mentioned above. Cultural contexts are more abstract. They are the systems of ideas, values, and beliefs that prejudice our reading of form and space. History and cultural traditions constitute a conceptual backdrop against which virtually all designs are viewed.

CHAPTER *3*

Plane and Space

INTRODUCTION

In two-dimensions a line (a one-dimensional object) can be bent and turned in one, many, or an infinite number of directions. Likewise, in three-dimensional space, a plane (a two-dimensional object) has the freedom to be folded and redirected through space one, many, or an infinite amount of times.

Lines, then, become free and active on a surface and planes become free and active in open space. Visual structure in two-dimensions is linear and, in three-dimensions, planar. Line divides and defines the areas of a two-dimensional surface, while plane divides and defines the volumes of three-dimensional space.

New Materials, New Forms

Since the third century B.C.E., when Euclid compiled all of the ancient Greeks' knowledge of geometry into one set of books, the role of planes in structuring space has been well known to mathematicians. But it was not until the past century that planar form and structure leaped to prominence in the three-dimensional arts.

Between 1850 and 1900 scientists and industrialists developed methods for mass producing glass, steel, aluminum, plastic, and other materials that were once expensive and unavailable. These materials could be rolled and extruded cheaply into sheets and bars, that is, into planar and linear forms. They offered the designer not just new materials, but a new vocabulary of form. Design construction no longer needed to be primarily volumetric, but could explore plane and line as well.

By the early twentieth century designers were pursuing innovative, viable designs of purely planar elements. Exploration of space, as expressed through planes and with an abstract language akin to the logic of mathematics, had become possible and eventually came to characterize much of modern sculpture and design.

INTERACTION AND STABILITY

In small-scale models, paperboards behave in a manner structurally similar to metals and plastics at larger scales. Many of the expressive and functional possibilities of these materials can be explored with easily constructed paper studies. Almost all artists who work with planar constructions begin their ideas as paper studies.

Experimenting with paper studies reveals that two planar forms can interact with one another in only one of three ways. First, two planes can meet at a common edge as when a paper shape is *folded*. Or, second, an edge of one plane can *abut* a face of another. Or, third, two planes can *interpenetrate*, that is, pass through one another.

While experimenting with paper studies you may find that some arrangements stand easily while others have a tendency to collapse. Part of the challenge of a good planar composition (or

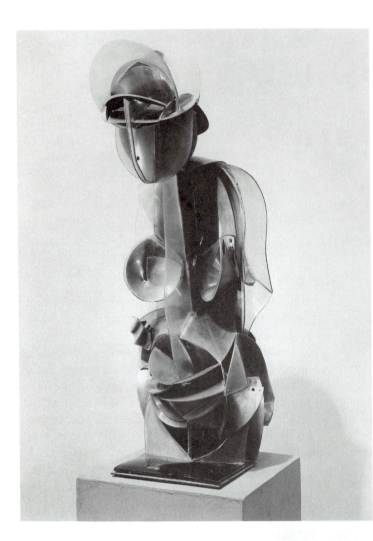

FIGURE 3–1 Antoine Pevsner, *Torso,* 1924–26. By the 1920s transparent celluloid and sheet copper were commonly available to sculptors and designers. Pevsner's reinterpretation of the classic torso into a construction of planes underscores the radical changes of form that such materials allowed sculptors. Note how Pevsner used the linear effect of the planes' edges to convey the suppleness of a torso.

Source: Antoine Pevsner, "Torso," (1924–26). Construction in plastic and copper, 29½" x 11⅝" x 15¼" (74.9 x 29.4 x 38.7 cm). The Museum of Modern Art, New York. Katherine S. Dreier Bequest. Photograph © 2000 The Museum of Modern Art, New York.

FIGURE 3–2 Robert Murray, *Nordkyn.* Murray has constructed bold planar constructions for a variety of public sites. The sculpture could have been assembled from shapes cut from a single large sheet of steel. The formal principles at work here can be explored by cutting and folding paper sheets. Most sculptors who work with sheet materials begin with paper models. Only scale and material may change in the translation from model to finished sculpture.

Source: Courtesy of Wayne State University—Media Relations, Michigan. Photograph by Robert Murray.

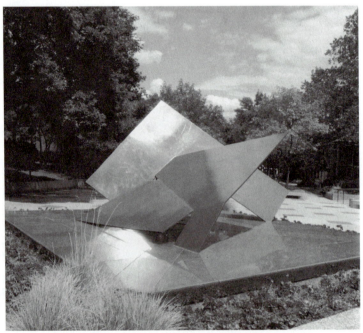

of any three-dimensional composition) is to co-ordinate *physical stability* with *perceptual dynamism.*

The simplest method for achieving stability is to remember the "three planes rule." This rule states that *a stable structure results when any three planes meet so that each plane interacts with both of the other planes.*

The closer their meeting is to 90°, the greater the stability. Try testing this rule by combining paper shapes so that each plane folds or abuts or interpenetrates with its two partners. All of your combinations will be stable. A curving planar form counts as two planes joined through folding.

ENVIRONMENTAL PLANES

Often the third plane of a stable structure is the surface to which a planar construction is attached. Thus, if two interacting planes are affixed to a wall, a tabletop, or the pavement of an architectural plaza those planes become stable by virtue of abutting this third structural plane. Any surface to which a planar structure is mounted, including a vertical or overhead surface, is called the *ground plane* of the structure.

The ground plane is a special example of an *environmental plane.* Walls, floors, ceilings, tabletops, the surface of the earth, shelves, etc., may all act as environmental planes since they

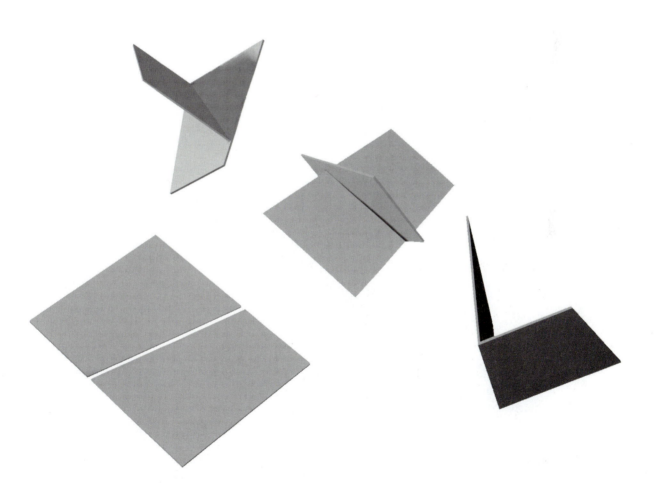

FIGURE 3–3 *Planar Interactions.* A single sheet of material, cut into two shapes, can rejoin as a three-dimensional form. Read diagonally from left to right these are: abuttal, interpenetration, and folding.
Source: Courtesy of the author.

FIGURE 3–4 *3-Plane Structures.* When three planes mutually interact through three dimensions, they will yield a stable structure.
Source: Courtesy of the author.

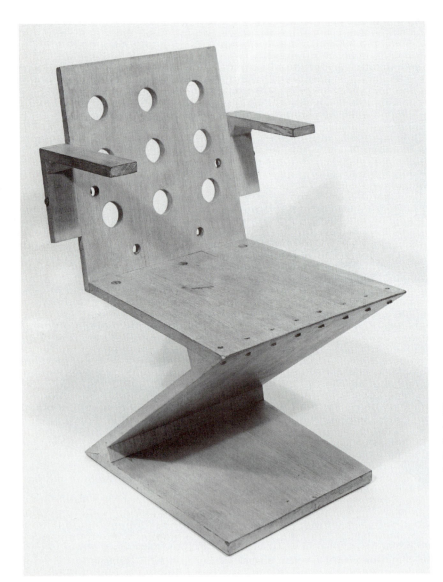

FIGURE 3–5 Gerrit Rietveld, *Zig-Zag Chair.* Rietveld was trained as a carpenter and his sense of the structural potential of wood was quite sophisticated. This chair emphasizes *folding* and appears to have no support. However, Rietveld wedged a third plane into each joint to brace his structure and thereby meet the "three-plane rule."
Source: Reproduced with the permission of the Centraal Museum, Utrecht.

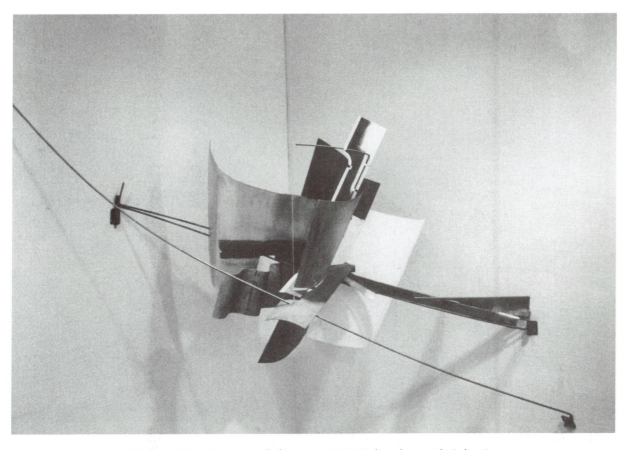

FIGURE 3–6 Vladimir Tatlin, ***Counter-Relief (corner)***, 1915. Tatlin, along with Gabo, Pevsner, Rodtschenko, and other members of the revolutionary Russian Constructivist movement, was among the earliest experimenters with planar form. Set in the corner of the room, this sculpture incorporates the two walls or environmental planes into its composition.

Source: Vladimir Tatlin, Counter Relief (corner)" 1915. Iron, zinc, aluminum. 78.8 x 152.4 x 76.2 cm, 31" x 60" x 30". Reconstruction from photos by Marilyn Chalk, 1966–70. Courtesy of Annely Juda Fine Art. Licensed by VAGA, NY.

can all help to define the space in which a planar object finds itself and in which that object is experienced.

ARCHITECTURAL PLANES

Most of the environmental planes listed above comprise the architectural environment in which an object might be located.

A special category of planar form is *architectonic* form. It deserves extra consideration because of its prominence in the world of man-made objects. This is the formal category of architecture, most furniture, and many other objects.

Architectonic forms abound in the designed world. Look around and take note of these features in our built environment:

(a) the regular geometric shapes featuring a preponderance of rectangles, triangles, and simple curves like circles.

(b) primary emphasis, for structural reasons, on horizontal and vertical orientations relative to gravity and a usually *orthogonal* (90°) placement of elements.

(c) the strong contrast of closed (interior) and open (exterior) space with emphasis on the transitions between these two types of space.

FIGURE 3–7 Katarzyna Kobro, ***Spatial Sculpture I,*** 1925. Perhaps the most important plane in this composition is the top of the table on which it rests. Like the other sculptures in Kobro's important series of Constructivist works, this piece relies on the tabletop to unify the composition. Under her hand the table is transformed into an open, plazalike space. From this space, the composition moves into more closed porchlike regions of space.

Source: Katarzyna Kobro, Spatial Sculpture I, 1925, metal, oil, 14 x 54 x 40 cm. MS/SN/R/15. Courtesy of Muzeum Sztuki w Lodzi.

From the outside architectural forms are perceived as solid masses and on the interior as volumes. But the walls, ceilings, roofs, etc., of buildings can be regarded as planes that close off and shape space.

TRANSITIONS

Windows and doors are physical apertures that allow transitions between closed interior and open exterior spaces by creating *perforations,* or holes, through the enclosing planes.

Purely visual transitions can be created through planes by means of transparent mate-rials or by means of architectural *screens.* Screens are architectural planes characterized by frequent, regular, and overall patterns of per-forations. Reflective surfaces like mirrors can also effect visual transitions by abetting the il-lusion of space entering into a closed surface.

Certain architectural spaces like porches, stoae, porticoes, and the like form semi-open or semi-closed spaces that create transitional spaces between open exterior and closed interi-or spaces.

The ease of visual or physical transitions from space to space is referred to as the open-ness of a composition. Open and closed space, the perception of access to or egress from a

space, is one of the most basic experiences of space.

Because architecture is an art of transition and passage it is highly *temporal,* its elegance unfolds in time as well as space.

PLANES OF SPACE

The planar shapes in a three-dimensional space are commonly referred to as simply "planes." However, the term, *planar segments,* more accurately describes them. This term differentiates them from the notion of *planes of space.*

Planes of space are planes in the mathematical notion of plane, where planes are envisioned as extending indefinitely through space. A planar segment is only that region of a plane of space that has been given a physical form. Two or more planar segments may lie on the same plane of space. Such segments are termed *co-planar.*

Like the notion of environmental planes, the concept of planes of space is very important in the understanding of compositions in space.

The distinction between planar segments and planes of space can be seen in an ordinary cafeteria: The top of each table is a planar segment, but the whole array of tabletops defines a

FIGURE 3–8 Walter Gropius, ***Room for the Director of the Bauhaus,*** 1923. (Drawing by Herbert Bayer.) Gropius repeatedly incorporated the rectilinear format of the architecture into the planes of the room's furnishings. These planes divide the room into a remarkable variety of *open* and *closed* spaces whose proportional variations inject dynamism and continuity into the space. Even the lighting fixtures maintain the perpendicular orientation of forms.

Source: Bauhausarchiv—Museum für Gestaltung, Berlin, Germany.

FIGURE 3–9 Jean Gorin. ***Construction of Plane Relations No. 1.*** (1931) An especially fruitful direction of Constructivism was its application of architectural concepts of space to sculpture. Gorin's architectonic planes, for example, steer the viewer from more *open* outer spaces through progressively more *closed* interior spaces.

Source: Courtesy of Professor Dr. Serge Lemoine, Musee de Grenoble.

FIGURE 3–10 Alexander Rodtschenko, ***Space Construction #5,*** 1918/1973. Perforations open the space of a planar composition and create *negative shapes* to generate richer and more complex shape activity. In this sculpture, Rodtschenko passes some of his planes through the perforations he has cut into his other planes.

Source: Alexander Rodtschenko, "Raumkonstruktion Nr. 5" (weibe gegenstandslose skulptur), 1918/1973. Aluminum, bemalt, 3/3 46 x 39 x 34 cm. Courtesy of Galerie Gmurzynska, Köln. © Archive Rodtschenko-Stepanova.

FIGURE 3–11 Beverly Pepper, *Venezia Blue.* Pepper relaxed her severely architectonic forms by subtly adding diagonals. Her planes are also highly polished and *reflective.* Reflectivity "softens" the hard steel surface by visually incorporating the outside environment.

Source: Beverly Pepper, "Venezia Blue." 7'8" x 3'4" x 2'7". 1968. Coll. Nasher. Courtesy of the artist. © Beverly Pepper/Licensed by VAGA, New York, NY.

FIGURE 3–12 Mughal India, *Jallied Verandah.* In addition to adding ornate decor to the architecture, screens ventilated buildings in hot climates. The screens also block direct sunlight, but let the cooler, indirect light enter.

Source: Photograph from "History of Mughal Architecture," vol. II. Courtesy of Professor R. Nath, Ph.D.

FIGURE 3–13 Henning Larsen, ***Interior, Ministry of Foreign Affairs, Riyadh.*** Danish architect Larsen updated the traditional screen art of Arabic architecture into strict, gridded lattices. The screens allow the architect to divide the space without relinquishing its visual continuity.

Source: Courtesy of Henning Larsen, Architect. Photograph courtesy Richard Bryant/Arcaid 17.390.2.

FIGURE 3–14 *Cafeteria Tables.* These tabletops represent *planar segments,* all of which lie on a single *plane of space.*

Source: Courtesy of the author.

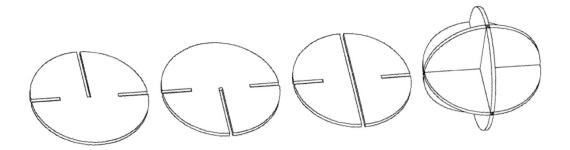

FIGURE 3–15 *Spherical volume 3—planes.* Often the term *planes of space* refer to the three primary planes of space that extend into the three dimensions of normal space. These three planes intersect at 90° to one another, and they subdivide normal space into front and back, left and right, and top and bottom respectively. The circles defining this spherical volume are set into each of these planes of space.
Source: Courtesy of the author.

FIGURE 3–16 *Closed and open cubic volumes.* A closed cube gradually disintegrates as one square plane after another is removed. In this arrangement, the volume of the cube remains apparent as the cube opens to the outside space. Note how the intervals between these cubes are also cubes.
Source: Courtesy of the author.

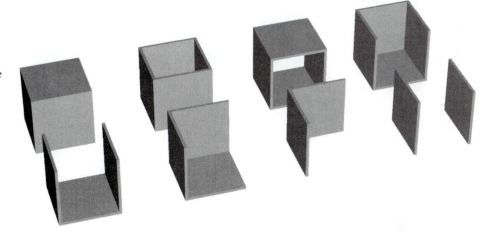

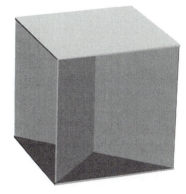

FIGURE 3–17 *Stereometic Cubes after Naum Gabo (*Model based on a concept by Naum Gabo). Gabo, one of the major early abstract sculptors and theorists, devised a method for portraying volumes with planes, which simultaneously defined both the outer edges and the interior of a volume. (Look closely at Figure 3–1 to see how Antoine Pevsner incorporated his brother's method.) Gabo's cube garnered highly stable structure and represents the minimum number of planes that can define all 12 edges of a cube.
Source: Courtesy of the author.

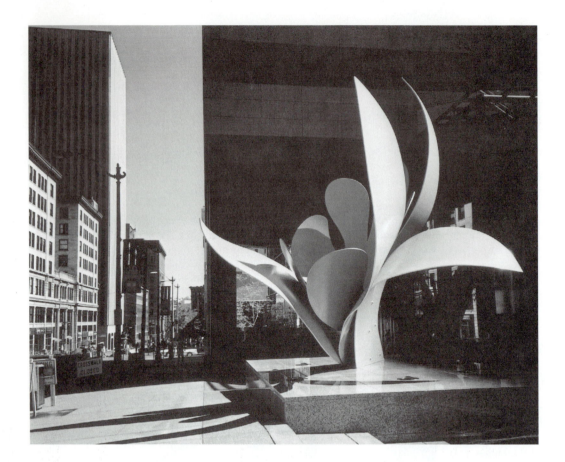

FIGURE 3–18 Tom Wesselman, *Seattle Tulip.* Wesselman's experience as one of the top painters of the Pop Art movement of the 1960s served him well in this foray into public sculpture. Shape and color, borrowed from the language of painting, sing in open space. His *graphic* shapes—pale green pointed leaves grasping a bright red cluster of petals—reverberate off the stark geometry of the urban environment. At the same time the energy of his forms echo the bustling life ensconced in that geometry.

Source: Tom Wesselman, "Seattle Tulip." Photograph courtesy of Jill R. Haley. Commissioned by Wright Runstad and Company, Seattle, Washington. Owned by Equity Office Properties Trust, Chicago. © Tom Wesselman/ Licensed by VAGA, New York, NY.

single plane of space. All of the cups and saucers on all of the tables rest on the same plane of space, but on different, co-planar segments of that plane.

PLANE AND VOLUME

Think of a plane as "slicing" space. Much as the blade of a knife slices through a block of cheese, dividing into two new chunks, so a plane divides and shapes space. This image entails picturing space as a sort of empty material that can be cut and defined by the "blade" of a planar shape.

At the same time this image confers a moving, active character onto planes and imparts to them the ability to activate space. The dual functions of planes are to shape and activate space.

Planes can also define volume by virtue or their shape. A circle, for example, can be pictured as a slice, or cross-section, from a sphere. A group

of circles that are all the same size and all intersecting such that their centers share the same point will describe a sphere in space.

PLANES AS SHAPE

Planes can be regarded as two-dimensional (or *graphic*) shapes thrust into a three-dimensional space.

The *graphic qualities* of shapes and the spatial character of planes share equally in the task of creating expression. Rectangular shapes, for instance, will reinforce the spatial divisions and orientations of architecture. However, designers may just as likely choose to contrast highly active shapes with stable structure so as to generate tension between shape and structure.

Graphic quality divides into two different, but interwoven categories: *form* and *sign*. Form qualities inhere in the shape itself—the brightness or dullness of its color, the smoothness or angularity of its lines. Sign quality, on the other hand, denotes how a shape can remind us of a thing or concept other than the shape itself: A silhouette may represent a person and a heart may symbolize love.

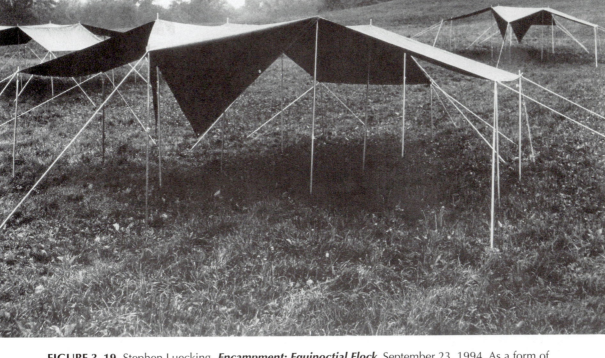

FIGURE 3–19 Stephen Luecking, **Encampment: Equinoctial Flock,** September 23, 1994. As a form of temporary, nomadic architecture, tents, too, are planar objects. These tents take on the *symbolic* form of both crosses and alighting birds. This flock aligns with a Pre-Columbian Mississippian temple mound and the rising sun at the fall equinox.
Source: Courtesy of the author.

Most graphic shapes wed form and sign with one reinforcing the other. Elongating and curving a cutout of an animal, for example, can add litheness and movement to the image. Form extends, adapts, and sharpens those meanings elicited by symbolic shapes.

Abstract, nonrepresentational shapes may also carry symbolic associations. Without portraying a particular plant or animal, a curvilinear plane can, nevertheless, convey more general qualities, such as flow or energy that characterize life.

CHAPTER *4*

Organization

INTRODUCTION

Organization is the overall pattern or structure that ties the parts of an object together into a united, sensible, and purposeful whole. In both two and three dimensions, organization derives directly from the purposes, the meanings, and the functions that the design is to serve.

Two-dimensional organization relies on visual structure, but in three dimensions organization comprises both visual and physical structure. This chapter concentrates on the organizational structures that operate on visual forces, while Chapter 10 explores the structures that deal with physical forces.

Synergy

The famous designer R. Buckminster Fuller used the term synergy to denote the unpredictable, often startling, capabilities that can emerge in an organization whose individual elements seem relatively unimpressive on their own. This is the idea expressed in the old dictum that "the whole is greater than the sum of its parts."

The soft darkness of common soot and the crystal glint of a precious diamond are consequences of the same ordinary atoms of carbon. The difference between dirt and jewel is the molecular organization of the carbon atom in the two minerals.

Order and Freedom

Human minds just naturally create order. Too often the greatest obstacle to compelling compositions is the inclination to be overly orderly. In design, as in life, interest, variety, freedom, and unexpected richness tend to lose out to the safe monotony of excessive order.

On the other hand too much freedom and too much variety can disjoint a composition. Excess freedom dissipates expression and produces the same net effect as monotonous unity: the loss of viewer engagement. The trick comes in interweaving order and freedom, unity and richness, and in choosing which to emphasize in achieving one's goals.

STRUCTURE AND UNITY

Grids are the most common examples of *systematic structures*. As an organizational device, a grid establishes a pre-set, or *a priori*, logic, which governs the relative position, direction, and scale of all the visual elements of a composition. By contrast, *intuitive structure* relies on the viewer's psychological experience of the visual interplay of elements to imbue a composition with a sense of order.

Typically, systemic structure relies on more formalized and mathematical applications of unifying principles, while intuitive structure

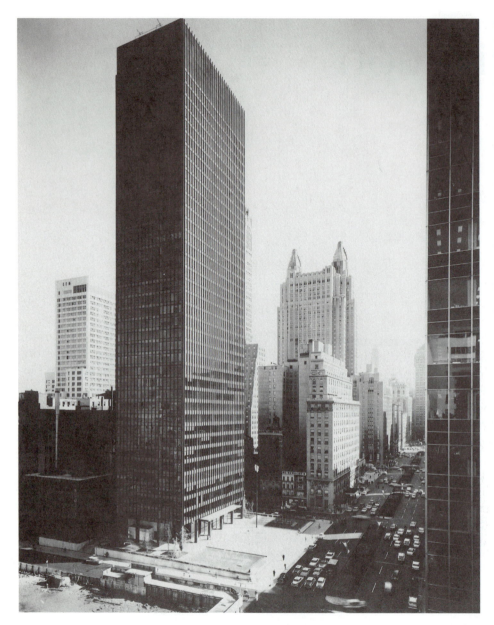

FIGURE 4–1 Mies van der Rohe, *Seagram Building,* 1954–58. Dominant through the mid-twentieth century, the International Style in architecture espoused logical design as an aid to a more rationally organized society. Ordered spaces enabled an ordered society, this movement believed. Most often this logic was expressed in the geometric simplicity and ordered repetition of the *grid* (Figure 4–2).

Source: Ludwig Mies van der Rohe, Seagram Building, New York City, 1954–58. Photograph courtesy of the Mies van der Rohe Archive, The Museum of Modern Art, New York.

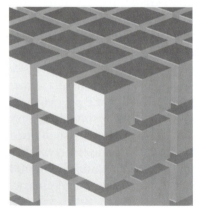

FIGURE 4–2 *3-D Grid.*
Source: Courtesy of the author.

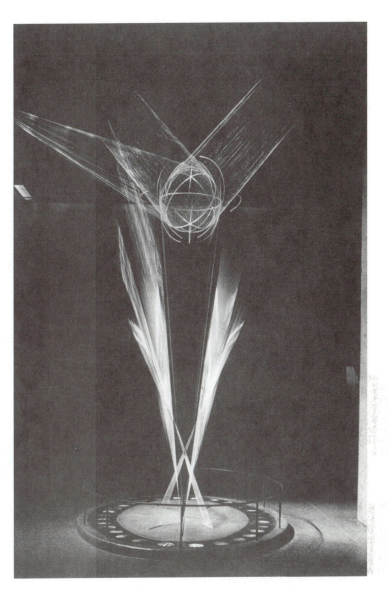

FIGURE 4–3 Richard Lippold, *Flight,* from the Pan American Building, NYC, 1963. The dramatic elegance of this groundbreaking public sculpture emerges, in large part, from its dynamic application of *symmetry.* The "V" and "X" grouping of lines possess *bilateral* symmetry, giving structure to their dynamic angles. The upper forms evince even greater symmetry, both *radial* and *spherical.*

Source: Courtesy of the artist.

relies on far less prescriptive applications. Unifying principles are perceptual devices that visually bind a composition together. Some of these principles are: *balance, repetition with variety, proportion, continuity, focus and emphasis, and economy.*

BALANCE

Balance ensures that two halves of a composition carry the same visual weight.

In three dimensions, balance must work from all points of view. The three-dimensional artist must successfully balance a composition visually and physically. Real gravity, not the perception alone of gravity, governs three-dimensional balance.

Balance may be *symmetric* or *asymmetric.* Symmetry balances a composition by systematically repeating patterns of form within a composition. Asymmetry counterbalances contrasting elements of equal visual and physical weight. Symmetry is often, therefore, the mark

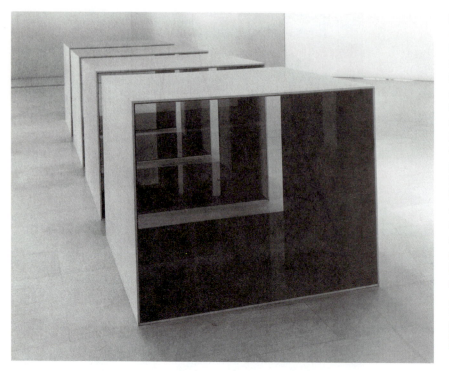

FIGURE 4–4 Donald Judd, *Untitled,* 1969. Minimalist sculptors like Judd were noted for reliance on repetition, and only repetition, to unify their compositions. By definition Minimalism eschewed the variety on which most artists relied to create visual interest. However, in Judd's *Untitled* work variety emerges as the viewer moves about the piece. Judd lined the interiors of his stainless steel boxes with clear blue Plexiglas to create a blue inner glow. From certain points of view the piece appears as a series of industrial containers; from other views it becomes a deep tunnel bathed in eerie blue light.

Source: Donald Judd, "Untitled (anodized aluminum and blue plexiglass)," 1969. The Saint Louis Art Museum. © Donald Judd/Licensed by VAGA, New York, NY.

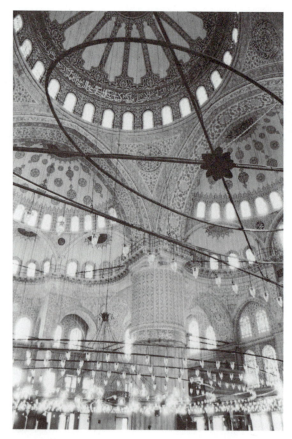

FIGURE 4–5 *Mosque lights.* The rings of windows, domes, and arches of this early medieval architecture are themselves a rhapsody of circular form. Modern lighting fixtures that repeat this circularity continues with a linear variation on the architectural masses and volumes. This photograph, in its study of light, has set the rings of electric lights against rings of sunlight.

Source: Mosque interior, Istanbul. Photo courtesy of Cary Smith Mondschean.

of systematic structure, while asymmetry typifies intuitive structure.

Symmetry

The most common symmetry in art is *mirror (or bilateral) symmetry,* perhaps because it is the symmetry of the human body. In this symmetry, one half of a composition is repeated by its reflection in the other half.

Two-dimensional mirror symmetry is reflected across a *line of symmetry,* while three-dimensional mirror symmetry reflects across a *plane of symmetry.* Any plane that divides an object into two mirrored halves is termed a plane of symmetry. A sphere has an infinite number of planes of symmetry.

Radial symmetry is another common symmetry. In three dimensions, it consists of repeated forms that may be radial from a central axis, like petals on a tulip, or spherical, from a central point, like seeds on a dandelion.

REPETITION WITH VARIETY

Repetition of the same or similar elements exerts order onto a composition. Too much repetition, too much order, however, emits a visual drone that blankets interest. Variety is needed to pique attention.

One or more of the formal and spatial characteristics of an element may be repeated, while one or more other characteristics may be varied. A single shape, say a sphere, may be used over and over, but its size and color may vary. A series of elongated shapes may differ sharply in appearance, but if they are all parallel and facing in the same direction, they will appear unified.

Repeating not just compositional elements but also specific relationships between these elements can exert a strong unity. Proportion is a particularly good example of such a relationship. The same proportional ratio, for example, when chosen to govern all of the individual scale relationships throughout a composition, effects order throughout the entire composition.

Rhythm and Gradation

Rhythm and *gradation* are two important applications of repetition with variety. Both entail the systematic repetition of *intervals of change.*

FIGURE 4–6 Kathryn Lehar, **Untitled,** 1978. Influences of Constructivism and Minimalism mark Lehar's work. This composition relies on repetition, but with *gradation.* The artist has folded a sequence of metal sheets along diagonals spaced *proportionally* from sheet to sheet. In the process, she gradually moves the folded forms outside of their frame.

Source: Kathryn Lehar, "Untitled." Painted steel, 4' high x 4' wide x 16½' long. Courtesy of the artist.

FIGURE 4–7 Kasimir Malevich, ***Gota 2-a,*** 1923. Malevich's 1923 plaster reflects the early Constructivists' interest in architectonic sculpture. Here Malevich concentrates on the architect's use of proportion, especially *modular proportion.*

His application of proportion creates a looser rhythm than the linear one-two beat of Judd's sculpture above. Contrast Judd's sequence of positive and negative intervals with Malevich's more organic clustering.

Source: Kasimir Malevitch, "Gota 2-a," 1923. Collections Mnam/Cci—Centre Georges Pompidou. Photograph: Phototheque des collections du Mnam/Cci.

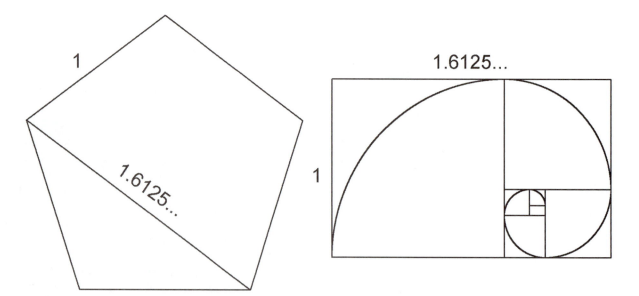

FIGURE 4–8 *Golden Section Proportion.*
Source: Courtesy of the author.

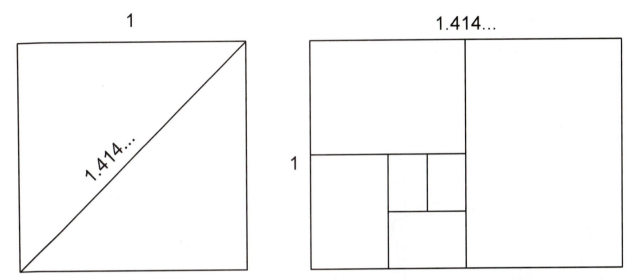

FIGURE 4–9 *Proportion Diagrams.* Above are diagrams of two unique proportional *ratios* common since ancient times. They are easily derived from simple geometric shapes, but can become complex in their properties. Both are irrational numbers, i.e., infinite nonrepeating decimals. Most fascinating—and popular—is the Golden Section. It appears in the growth patterns of nature and abounds in architecture since early Egypt. Take away a square from its rectangle and another rectangle of exactly the same proportion remains. Draw arcs through a succession of these squares and the resulting spiral corresponds to growth spirals of seashells and other natural forms.

The square root rectangle also holds a unique proportional division: fold it in half to get two rectangles of exactly the same proportion. When paper was a precious commodity, its sheets were produced in this proportion because books could be folded from it with no waste.

Source: Courtesy of the author.

In rhythm one or more intervals are set up in short succession with that succession repeated through out the composition. *Polyrhythmic* compositions interweave a number of rhythmic patterns. They gain richness in their compounding and contrasting of multiple rhythms.

Gradation uses intervals of change in a progressive series and sets a path for the eye to follow. For instance, forms may grow smaller bit by bit or they might gradually shift their color or shape.

PROPORTION

Proportion is the measure of the relative change of scale between the elements of a composition.

Modular Proportion

A proportional system that limits incremental changes of scale to a single unit of measure is called *modular proportion*. The unit of measure, for instance 1" in a small paper project, is called the *modulus of proportion*. The size of the modulus is arbitrary, but consistent throughout a composition. Thus 6½" cubes with a 1⅝" modulus is proportionally equivalent to the 4" cubes divided into 1" modules.

Architects typically build houses using modules of either 16" or 24" to space wall studs, floor joists, and rafters, and to proportion the sizes of their rooms. These figures derive from three parameters: the scale of the human body, the strength of lumber, and the economizing of material. Standard 4' x 8' pieces of plywood or

FIGURE 6–1 Else Moegelin, ***Plas-tiche Studie aus dem Vorkurs Bei Jo-hannes Itten, Bauhaus, Weimar,*** 1921. Created when she was still a student at Germany's Bauhaus, Moegelin's plaster sculpture exploits only *interpenetrating* cubes.

Source: Bauhausarchiv—Museum für Gestaltung, Berlin, Germany.

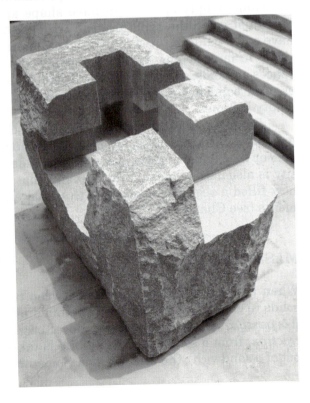

FIGURE 6–2 Eduardo Chillida, ***Deep in the Air-Stele XIII,*** 1990. When encroached by shaped spaces, *monolithic* masses, such as a block of stone, can become activated and engaging forms. Chillida's labyrinth of honed rectangular volumes starts as relatively shallow *concavities* then burrows on into the block to become a *penetration* deep into its center. Should these se-quences of space continue to emerge from the opposite sur-face, they will have bored a *perforation through the stone,* as do the voids in Henry Moore's sculpture (see Chapter 1). In this case, the hollows are more rigorously formed than the block it-self.

Source: Photograph: Eduardo Chillida, "Deep in the Air-Stele XIII," 1990. Granite, unique. 48¹³⁄₁₆ x 41⅜ x 68⅛ inches. Courtesy of the Tasende Gallery, La Jolla, CA.

FIGURE 6–3 *Bald-Face Hornet Nest.*

Source: Courtesy of the author.

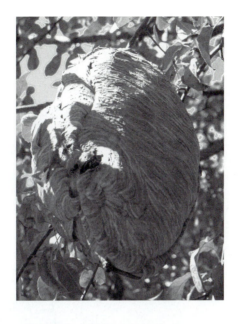

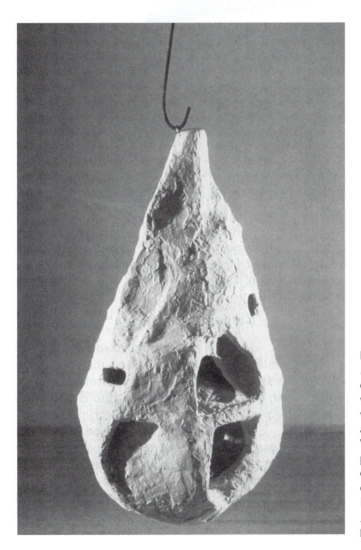

FIGURE 6–4 Louise Bourgeois, *Fairy Dressmaker (Fee Couturiere),* 1963. Hundreds of hornets built this nest *additively*—with mouthful after mouthful of chewed wood pulp. Bourgeois borrowed her image, a fairies' lair, from such insect structures. Where the hornets accreted striations of paper, the sculptor modeled layers of plaster over an armature. Deeply penetrating voids open the interior to habitation by her half insect/half human tenants.

Source: Courtesy of Louise Bourgeois. Photographer Louise Bourgeois Studio.

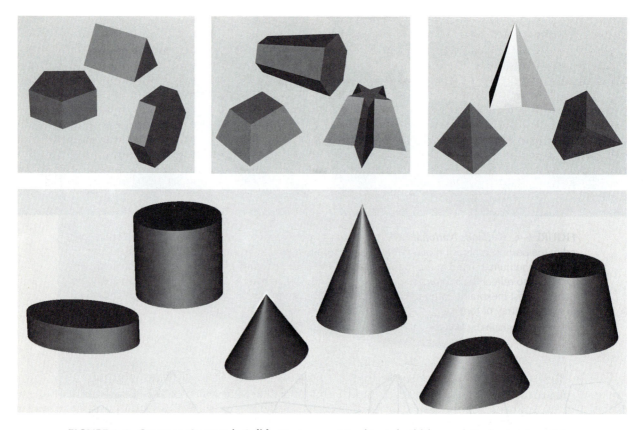

FIGURE 6–8 *Common Geometric Solids.* Most geometric objects build from relatively simpler solids. *Prisms* are solids whose end planes are equivalent polygons and whose sides are usually rectangles. *Pyramids* rest on polygonal bases and their triangular sides taper to a point. Cutting off, or *truncating,* this point yields a solid whose end planes are similar, but unequal, polygons. *Cylinders, cones,* and *truncated cones* correlate with prisms, pyramids, and truncated pyramids. Their bases and sides, however, are curved rather than polygonal.
Source: Courtesy of the author.

is an example of this approach used with soft materials.

GEOMETRIC VOLUMES

The vast majority of shapes in the built world are versions of *prisms, cylinders, pyramids, cones, truncated prisms,* and *truncated* cones or their combinations.

Under a geometer's analytical eye, a hockey puck is a short cylinder, while a paper cup is a truncated cone. Simple geometric volumes, both positive and negative, may combine and interact to create more complex objects. A rural mailbox is half cylinder and half rectangular prism supported horizontally on a vertical post, itself a tall cylinder.

Spherical Polyhedra

Less common than the above volumes are the *spherical polyhedrons.* These are polyhedrons whose vertices fit evenly into a sphere. Their visual and mathematical elegance has fascinated thinkers and designers since the age of Stonehenge. The five regular polyhedrons, whose sides and faces are all equal, are sometimes referred to as the Platonic solids because of the ancient Greek philosopher's mystical interest in these figures.

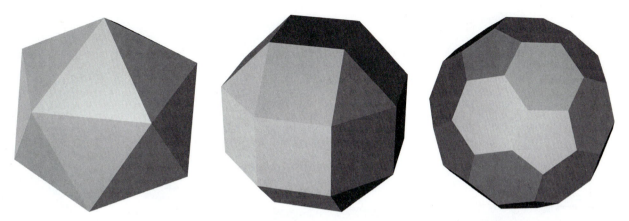

FIGURE 6–9 *Spherical Polyhedrons.* Some of the most common and elegant of the spherical poly-
hedrons, the icosahedron, the cuboctahedron, and the truncated icosahedron are also the most useful
in natural and human structures. Many contemporary domes derive from icosahedral geometry, as do
the shells of viruses. The cuboctahedron underlies the geometry of many inorganic molecules as well
as the space frames introduced in Chapter 9.
Source: Courtesy of the author.

FIGURE 6–10 Lincoln Schatz, ***Veer,*** 1997. The multiple planes joined on the surfaces of Schatz's
sculpture suggest an industrial entity straddling the realms of the geometric and the organic. By the
gradated repetition of polygons a curvature develops. Along with the dynamic orientation of the over-
all shape, this curvature contributes to the lifelike feel of the sculpture.
Source: Courtesy of Lincoln Schatz.

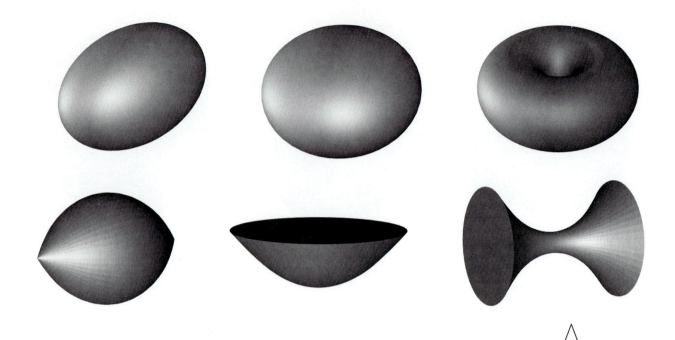

FIGURE 6–11 *Spheroids.* Spheroids are the class of geometric solids created when *conic sections* are revolved. Conic sections are the curved figures produced by slicing a cone. These are *circles, ellipses, parabolas,* and *hyperbolas.* In the first two figures of the top row, an ellipse rotated on its long axis has generated a *pronate spheroid;* rotated on its short axis it has produced an *oblate spheroid.* The last figure in the row is a *toroid* generated from a circle rotated around a point set outside of its circumference. The solids in the second set are all *hyperboloids* generated from the same hyperbola rotated around different axes.

Source: Courtesy of the author.

Spherical polyhedrons do show up in everyday life. Soccer balls, for example, are sewn in the pattern of a truncated icosahedrons.

Many of the spherical polyhedrons possess intriguing spatial properties that have spawned useful, yet elegant structures. For example, some have space packing properties, i.e., the ability of certain solids to neatly fit together and fill space, produces space frames and modular structures. Spherical polyhedrons are also the bases for geodesic domes, a highly efficient method for enclosing large, unbroken architectural spaces.

Space frames, modular forms and geodesics are covered in Chapter 9.

Spheroids

Certain geometric figures share, along with organic volumes, the properties of integrate surfaces. The simplest of these is the sphere.

The sphere is the three-dimensional correlate to the circle. Just as the circle demonstrates the most surface bounded by the shortest line, so a sphere evinces the most volume surrounded by the least surface.

A circle is just one of a category of geometrically related curves called *conics* that includes ovals and parabolas. Slicing a cone at various angles will reveal these curves. Conic curves can

rotate in space to generate a class of geometric volumes called *spheroids.*

An oval spun around its shorter axis will describe an *oblate spheroid,* i.e., a flattened sphere. Spin an oval around its longer axis and an elongated, football-like volume, a *pronate spheroid,* appears. Similarly a circle will sweep out a doughnut-shaped volume, or a *toroid,* when spun around an outside point. *Paraboloids* and *hyperboloids,* both of which look like blunt rounded cones or hourglass-like figures, are further examples of spheroids.

Unlike cones and cylinders, which curve in only one plane of space, the spheroids' *double*

curvature endows their surfaces with high structural strength. Thin materials, such as those used in planar construction, are especially strong when fashioned into surfaces with double curvature.

Spheroids lend the austere elegance associated with geometry, while maintaining the continuity and flow of an organic form.

FORM IN NATURE

Curves are the forms of life. One could search far and wide and never spot a truly straight line

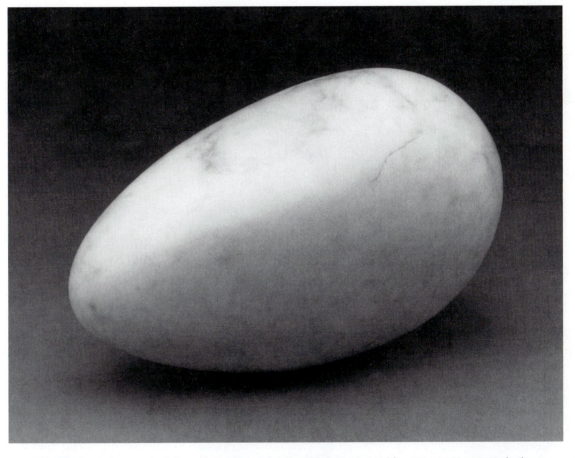

FIGURE 6–12 Constantin Brancusi, ***Sculpture for the Blind,*** 1916. Marble, 6¾" x 11¼" x 7". Only the vestigial jut of a jaw and the slight center ridge of a face modulate the surface of a near perfect spheroid. From a primal egg the form of a human head starts to emerge, like the awakening of a thought.

Source: Photograph by Gratdon Wood, courtesy of the Philadelphia Museum of Art: The Louise and Walter Arensburg Collection.

or a true angle in a living creature. In nature straight lines and angles are the reserve of inorganic, crystalline matter.

The reason for the crystalline character of inorganic form is far simpler than the reasons for the curves that characterize organic form. The molecules of inorganic matter align in regular geometric grids, or *lattices*, which determine how a mineral may split and fracture. Diamond cutters, for example, are highly trained in the art and science of determining the fracture pattern of diamonds.

Biomorphic Form

Organic molecules on the other hand are much more complex and irregular, less inclined to follow the crisp ordering of a geometric lattice. However the main reasons life takes on curved, or *biomorphic*, shapes has more to do

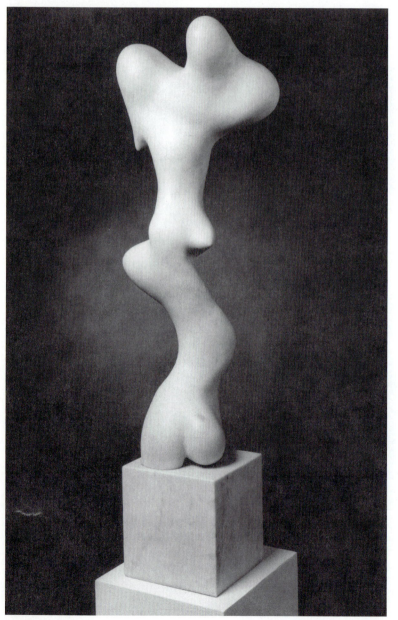

FIGURE 6–13 Jean Arp, ***Growth (Croissance), 1938.*** Along with Brancusi, Arp was one of the founders of abstract sculpture in the early decades of the twentieth century. Rather than depict a particular form of life, he sought to express the vital force, which he believed underlay all life. In order to do so, he shaped marble into a sleek, continuous surface that tensed and bulged as if from an inner force.

Source: Jean Arp, Growth (Croissance), 1938. Marble 80.3 cm (31⅝ inches) high. Solomon R. Guggenheim Museum, New York. Photograph by Robert E. Mates. © The Solomon R. Guggenheim Foundation, New York.

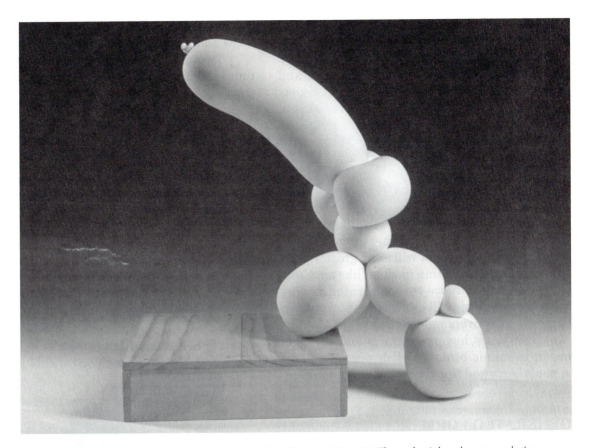

FIGURE 6–14 Jo Hormuth, from ***Frozen Turkey Dinners,*** 1994–95. Through trial and error evolution has developed the streamlined curves of fish and birds in order to efficiently deal with the stresses imposed by the media, water and air, in which they move. Internal pressure also contributes to the swellings of organic surfaces. Where Arp carved stone to create the illusion of inner stress, Hormuth cast balloon animals, thereby preserving the curves created by air pressing against their latex skin. The results are inventive zoomorphs embodied in images from a child's birthday party.

Source: Reproduced by permission of Jo Hormuth. Photo credit by Tom Van Eynde.

with the internal and external stresses placed on life, and the fact that life forms are animate, i.e. they move.

Over the large time spans required of evolution nature has learned, through trial and error, to distribute these stresses most efficiently and to design for locomotion. The design solutions have always adopted curved forms.

Mind and Geometry

The design solutions by humans, though, have leaned toward geometry. In fact, in the world of form, the single most apparent source of geometric form is the human mind. Look at the room you are in and at its furnishings; look at the shape of this book and the alignment of its print.

Humans tend to analyze their world into the mental, abstract shapes of geometry and, in building the artifacts of their cultures, tend to impose that form onto their world.

STRESS CURVES

A water filled balloon can be squeezed by hand into myriad shapes, but none of these shapes will be straight and angular. Hydraulic pressure pushes the balloon's elastic skin outward while fingers and palms exert pressure inward. The shapes are a result of stresses created on the

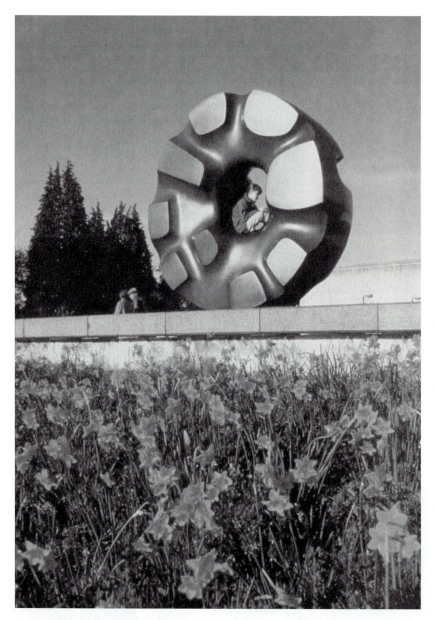

FIGURE 7–2 Isamu Noguchi, *Black Sun.* Noguchi's huge black circle of marble presents a simple and strong silhouette against the sky. Its outline is not a perfect circle, but a sinuous approximation that generates tension between the ideal and the actual. A similar tension emerges from the sculptor's hard-edged surface shapes that strike a balance between circles and rectangles.

Created for Seattle's public art program, the shapes recall the patterns of native art in the American Northwest (see Figure 12–3). The edges demonstrate a clear use of *contour* to add graphic strength to the surface forms.

Source: Photograph courtesy of the City of Seattle Arts Commission.

Applied Line

Line may be applied in order to activate previously formed surfaces. The artist/designer may, in effect, draw onto the object. This drawing may be *marked, incised,* or *appliquéd* onto surfaces. Markings are lines, which are simply painted, printed, penciled, etc. on the object. Glazing in ceramic art is perhaps the most common use of marking. Incisions are cut into the material. When the cut runs through a surface layer of material to expose a contrasting color underneath, it is termed *scrafitto*. Appliquéd lines affix to a surface. These may be of the same material as the object or another material collaged onto the surface.

Decoration

Applied lines add a graphic character to the surface of an object, because they borrow from the visual language of drawing and decoration.

A *decoration* is any surface enhancement that is not integral to the spatial form. Decorations when used by the three-dimensional artist *are,* however, *integral* to the overall *meaning* of the object. A decoration should always enhance rather than detract from its three-dimensional context.

Generated Surface

A series of parallel straight lines in space will define a flat, or neutral, surface. Gradually rotating the lines in sequence will introduce a twist into the surface. Systematically curving the lines will cause the surface to undulate.

The previous chapter introduced cross-sectioning with planes as a method for generating a volume. Replace the planar shapes with a sequence of wires bent into closed loops of the same shapes and the result is a purely linear rendition of the same volume. In such a volume, the sequence of lines described by the edges of the planar cross sections generate the volume's surface.

FIGURE 7–3 Aegena, Greece, ***Greek Vase,*** ca. 650–675. The line *applied* to the painted vase is a superb example of decoration used to articulate form. The drawing of the griffin's head overlays the sculpted head with graphic detail, while the patterned bands animate the body of the pot. Note how the patterns on the griffin's neck act as a transition between the pot's representational head and abstract body.

Source: Copyright The British Museum.

FIGURE 7–4 Pablo Picasso, ***Bather.*** The bather illustrates a unique interpretation of *scrafitto.* Craftsmen interpreted a folded paper drawing by Picasso into slabs of white concrete, and then sandblasted grooves to reveal the black pebbles embedded in the concrete. (Due to Picasso's death there is some question as to his authorship or approval of this interpretation.)

Source: Courtesy of Carl Nesuar. Sculpture in sandblasted (exposed aggregate) concrete, in collaboration with Pablo Picasso for Gould Corp., Rolling Meadows, Illinois, 1975.

FIGURE 7–5 *Egg crate Surface.* The top edges of these upright *cross sections* are lines, and it is these lines that define the undulating surface. One sequence of edges comprises straight lines. As they progress, they gradually change direction and generate a curved surface. In a second sequence the same surface generates from lines that fluctuate from *positive to negative curvature.*

Source: Courtesy of the author.

FIGURE 7–6 *Generated Surface Model.* Less regular and more agitated surfaces can also generate from lines. This digital model shows the generating line at the end stages in its sequence of random change. A close look will reveal *contoured edges* analogous to the edges in the cross sections above.

Source: Courtesy of the author.

FIGURE 7–7 Adam Leventhal, ***Boise FLight.*** If the designer chooses to isolate only the contour edges of a form and renders these as lines in space, the result is a three-dimensional drawing, a *wire-frame* version of a volume. In this sculpture for the Boise, Idaho, airport, Leventhal delineates the thin curvaceous volumes of wings by using metal tubing. This serves a practical purpose in that it lightens the large forms so that they might cantilever from the edge of the parking structure. The change in position from wing to wing defines a stop-action flapping as drivers pass the sculpture, and the cantilever is needed to thrust the massive wings into space. Visually, the wire frame allows viewers to see all surfaces of the wing from any point of view.

Source: Courtesy of Adam Leventhal

This linear depiction of a volume is commonly called a *wire frame* model of the volume. Wire frame renderings are commonly used to visualize volumes in computer-generated environments.

LINE AS OBJECT

Stretch a mass or volume far enough and it appears as a line. When an elongated mass is still relatively thick, as with a stone pillar, it is termed a *linear mass,* or, in the case of a tubular form, a *linear volume.* Draw out the mass to the thinness of a wire strand, and the perception of mass virtually disappears.

Divorced from surface and thrust into space, lines function as objects in their own right. Their task of defining and articulating surface upgrades to that of defining and articulating space. Line as form deals with the notion discussed above of a drawn line as a long attenuated shape.

FIGURE 7–8 John Henry, ***Bette Davis Eyes.*** Henry's work unlocks giant beams from their architectural cages and frees them to amble across space. Here, he loosely deploys the beams into two segmented lines. The two lines become characters in a minimal narrative: starting separately the two lines cross, intertwine on the same path, and finally separate again.
Source: Courtesy of John Henry, sculptor.

Shape, Path, and Narrative

Every line describes a story of sorts, which is "read" as the viewer follows it on its path through space.

Good stories need good beginnings, strong endings, and interesting plots to carry the reader along. Lines possess such narrative qualities in that they may begin and end abruptly, gradually, raggedly, or smoothly; their paths may be swift, torturous, jagged, or energetic. Their paths may rise and fall, dip and swerve, as they wend through space. Both form and direction determine the nature of the line's path, of the story it has to tell.

Complex linear compositions rely on interacting lines of individually strong character,

much as a novel builds on intertwining plots and subplots.

Dividing and Structuring Space

Draw a meandering line across a sheet of paper. Take a scissors and cut along this path. Two shapes will result. The line has, in conjunction with the format, defined these shapes by creating boundaries or edges. The edge of a shape is a line.

In three-dimensional space, lines define the edges of planes, which in turn defines volumes, conferring space with shape and form.

Structural lines are physical or implied lines that serve to divide a composition into proportional areas or to determine positions for the

elements in a composition. The lines of a grid, for example, do both by creating regular structured divisions of a format and by providing a regular system of placement for visual elements.

The skeletal grids supporting most architecture not only provide structural firmness, but visual structure as well. The structural systems introduced in the next chapter, for example, divide space into repeated volumes, imbuing it with a rhythmic cohesion.

PATTERN AND DENSITY

With certain drawing techniques, such as cross-hatching, artists use line to create patterns and

FIGURE 7–9 Francois Morellet, *Sphere-Frame,* 1962. Constructivism grew to become one of the dominant movements of twentieth-century art. During the 1960s it took on an even more analytical and technical edge than its early twentieth-century version. This beach ball-sized sphere uses a precise grid of stainless steel rods to define a volume in geometric contrast with its rectilinear structure. While the rods divide the interior into systematic blocks, the endpoints define the surface of sphere.
Source: Courtesy of Nicolas Davies Gallery.

FIGURE 7–10 *Tree Volumes.* Like fingerprints on the human hand, no two trees branch exactly alike. However, within each species the branching *pattern* will be similar enough that the trees will adopt the same general profile. Landscape designers count on this adherence to a standard volume in choosing which species to plant where. Designers choose species for the scale, sculptural volume, and visual texture they bring to a landscape.
Source: Courtesy of the author.

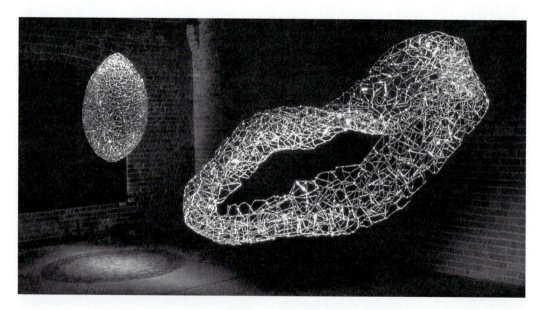

FIGURE 7–11 Anna Skibska, ***Breathe*** (foreground) and ***Slightly Uneven*** (background). Skibska assembles dense meshes of tiny glass lines that are physically fragile and visually ethereal. This is in part a result of the transparency of glass and partly due to the glinting of the reflected and refracted light. The shortness of Skibska's lines combined with the light scintilla conveys a state of continual shifting from materiality to light and back again. These sculptures are very nearly *point clouds:* volumes defined by a cluster of points.
Source: Courtesy of Bullseye Connection Gallery.

textures. Increasing the repetition of line will impart a denser, heavier feel to an area of a drawing. Repeated insertion of lines into a volume of space will similarly impart pattern and density in three dimensions.

The most readily available examples of line density are the different frequencies in the branching patterns of trees. In sparsely branching species, the limbs seem more individual, moving separately through space. With dense, frequently branching trees, the limbs merge into patterns and the volume of space occupied by the tree begins to fill out into an airy mass.

Line density, then, allows a perception of space, which lies on a continuum between, mass and void: a condition where a volume of space is not filled but neither is it voided.

LINE, POINT, AND DEMATERIALIZATION

If we think of a leafless tree as a volume filled with intricate branching lines, what then is describing the surface of that volume? The answer is the aggregate tips of all of its branches. If one could eliminate the trunk and branches of a massive oak and leave only the endpoints of each branching twig suspended in space, the volume of the tree would remain apparent. A fuzzy surface of irregular points would surround a roughly spherical void and define the same huge space of the original tree.

Point

Very small three-dimensional objects—a marble, a light on a Christmas tree or a tiny seed—may all function visually as points in space. However, very small protuberances and indentations, nodules or pricks, on the surface of an object may also represent points. As with line, point may manifest as an attribute of the surface of a larger form or as a form in its own right. Unlike line, point has no direction—only position. Alone, then, it can do little to activate space. In aggregate, however, points create lines,

FIGURE 7–12 Otto Piene, ***Corona Borealis.*** Integral to the Constructivists' almost scientific investigation of form was a fascination with technology. Most often this translated into integrating sound, light, and movement (see Chapter 10) into the object. *Corona* congregates 400 *points* of light into one dense sphere. The *density* imparts a sense of mass to the light, which pulses as if alive.
Source: Courtesy of Otto Piene.

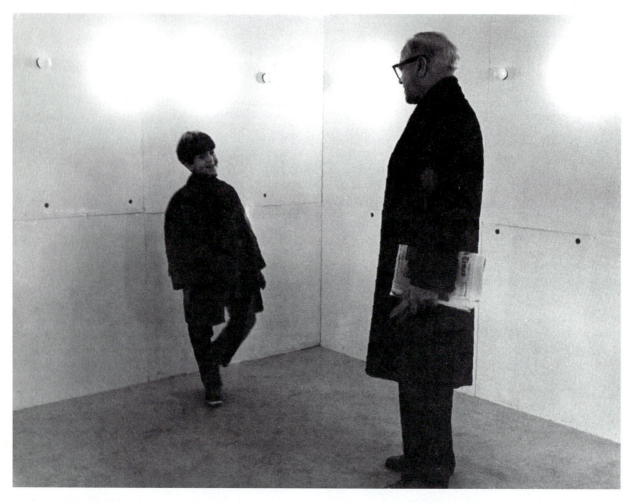

FIGURE 7–13 Hans Haacke, ***Photoelectric Coordinate System.*** This room is enmeshed in a grid of in-
visible lines. Beams project from sets of regularly spaced electronic sensors to equivalent sets of sen-
sors on the opposite walls. When visitors enter the space, they interrupt these unseen electron beams.
When a beam is interrupted, the corresponding pair of sensors lights up. These points of light serve as
a read-out to mark the coordinates of the viewer's position in the room.
Source: Courtesy of Hans Haacke. © Han Haacke/VG Bild-Kunst/Artist Rights Society (ARS), NY.

shapes, planes, surfaces, and volumes. They are
the atoms of space.

Dematerializing Form

As seen in this and previous chapters, the
same three-dimensional space can dematerial-
ize from a solid form to a set of planes, to a
bunching of lines, or to a galaxy of points—and

still retain its definition, its demarcation of
space.

Abetted by the possibilities of new technol-
ogy, the past century's aggressive probing of the
nature of form and perception has often displayed
a trend in sculpture and design toward this sort
of dematerializing. Lightweight structures, Min-
imal/Conceptual sculpture, and electronically re-
alized spaces all exemplify this trend.

CHAPTER 8

Color and Material

INTRODUCTION

All the conceptual elements of form—*point, line plane,* and *volume*—and their interrelationships constitute the mental blueprints that the designer draws upon to shape material into form.

The viewer responds to the volumes, shapes, and lines that have given the material its visual elegance and spatial structure. But the viewer responds also to the materials used to create a form and to the visual properties of the materials, especially *color* and *texture*.

Materials are not just visual addenda to form in space, but are the means to realize it. Form is impossible without material substance. The physical properties of material determine its structural potential and—as seen in Chapter 3—new materials can determine new forms.

In addition to color, texture, and structural potential, materials resonate with cultural overtones. These are the subtle, or not so subtle, reminders of the cultural situations and uses associated with a material. Wood, for example, seems warmer and closer to nature, than stainless steel, which can emit a cool and technological note. These overtones sound the cultural, symbolic meaning of these materials. A material's meaning integrates both form and *symbol*. Wood's earthy browns and rippling grain combine with its rustic references in a designer's expressive statement. Likewise stainless steel's grayed whiteness and hard sheen join with its technological references to contribute to an object's purpose.

INHERENT AND APPLIED COLOR

Materials are often chosen as much for their *inherent color* as for the physical properties they can contribute to a three-dimensional structure. The pure white of a Colorado marble, the purplish cast to a tropical hardwood, or the fiery glow of polished copper are all examples of strong colors inherent in their respective materials.

Color Applications

A color can also be an *applied color,* such as paint that coats the material. Paint is applied to material whose physical characteristics might be right for the design but whose inherent color is unexciting or incorrect for the artist's aims.

Sometimes artists use paint to hide the structural material in order to cancel out any psychological impact or cultural references that material might possess. Instead, the viewer sees the object as a congregation of lines, planes, and volumes shaped from chunks of color only. The form of such objects becomes, thus, more idealized or "pure" and less physical than those in which the material plays a strong visual role.

Two types of applied coloration that can change a material's color without canceling out its physical appeal are patinas and stains. When an applied color is created by the chemical treatment of a material's surface (usually metal) rather than with a paint coating, the coloration

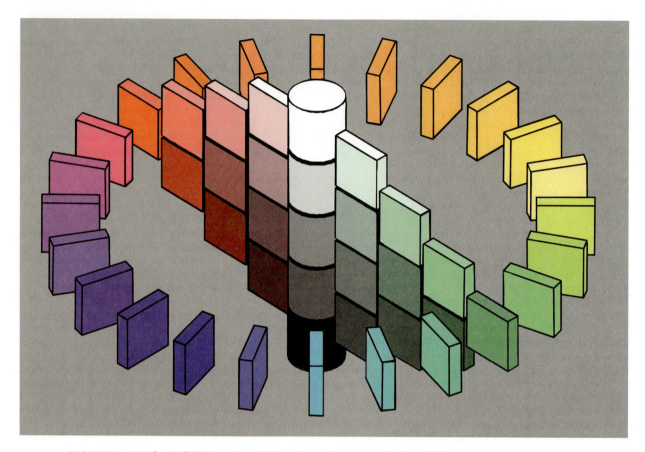

FIGURE 8–1 *Color Solid.* The *color solid* is a three-dimensional scale of all possible colors. The "equator" of the solid is a ring of pure colors, or *hues,* called the *color wheel.* The hues comprise all the colors of the spectrum. As colors near the center of the color solid, the amount, or *saturation,* of hue decreases and the colors grow increasingly black, gray, or white. By the time the colors reach the axis of the solid, they have lost all of their hue (or chroma) and are termed *achromatic* colors. Those colors desaturating toward white are *tints;* those desaturating toward gray are *tones;* and those desaturating toward black are *shades.* The scale of colors between black and white is often referred to as the *value* scale, as it is used to measure the light value, or darkness/lightness, of a color.

 Artists can specify any color by stipulating its hue, its degree of saturation and its relative value. These are the three dimensions of color.

Source: Courtesy of the author.

is called a *patina.* The verdigris, or greenish, coloration of ancient bronzes is a well-known patina. The surface of steel, too, can oxidize into browns ranging from near yellow to deep purples and blacks.

A stain or dye is applied to a porous material to change its color while maintaining its surface characteristics. Even certain low-density metals, like aluminum, are routinely dyed by a method known as *anodizing.*

ILLUMINATION

Illumination from a colored light source or from reflected light can color the surface of an object. Theatrical set designers and interior designers make most obvious use of color illumination, but sculptors, craftsmen, architects, and others will sometimes select materials for their reflective qualities or for their ability to accept reflected coloration. Polished copper, for instance, will

FIGURE 8–2 Jerry Peart, **Splash,** 1986. Peart is noted for his active planar compositions and his equally active colors. He paints his welded aluminum forms with highly *saturated* colors and transforms them into solid slabs of colors that seem to have come to life. The aluminum substrate is completely hidden: Its purpose was to create a strong, lightweight structure and a surface highly receptive to paint. The artist's goal is to achieve a sculpture seemingly fabricated from color itself.

Source: Courtesy of Jerry Peart.

FIGURE 8–3 Bruce Beasley, **Offspring II,** 1995. Looking like a cross between urban architecture and desert mesas, this sculpture has strikingly expressive surfaces. Beasley has exploited the reactivity of bronze to a wide variety of chemicals to create an earthy rainbow of *patinas.* Since the patinas are chemical changes in the bronze itself, this type of coloration preserves the import of the material's *texture.*

Source: "Offspring II," cast bronze, 1995. 5" h x 9½" w x 7½" d. Courtesy of Gwenda Jay/Addington Gallery/Bruce Beasley.

reflect flamelike colors that will project dramatically onto a white material.

Transparent panes of stained glass or colored translucent plastics may also be employed within a design to cast colors on neighboring forms or to act as colored filters through which other forms might be viewed.

TEXTURE

Texture is both visual and *tactile*. Most visual responses to texture are through tactile associations, relying on past experiences of having touched other similarly textured surfaces.

Tactility elicits very physical and direct responses: the body and not just the eyes sense texture.

A velvety surface will likely lure the viewer and invite touch. A splintered surface will tend to repel touch. Smoothness and roughness describe degrees of surface agitation, in which smooth surfaces are calmer, while rough surfaces are more disturbed.

The descriptive words in the last paragraph, "invite," "repel," "calm," "agitated," and "disturbed," assign emotional responses to texture. Texture touches emotions more than logic, and thus correlates with the kind of psychological moods evoked by color. Between blue and red, the calmer

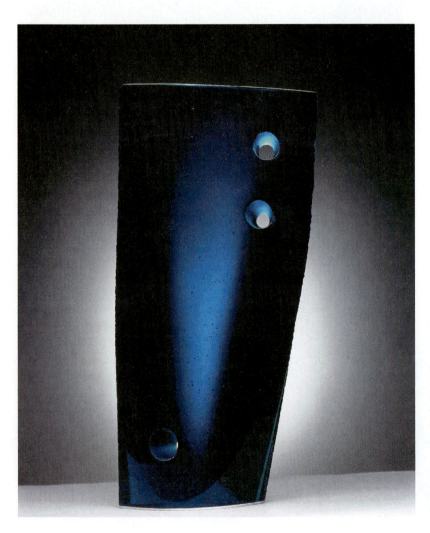

FIGURE 8–4 Richard Whiteley, **Blue Wedge.** Stained glass is arguably the most dramatic example of *inherent* color. In the hands of a master craftsperson, it takes on a crystalline lucidity that mimics light itself. Light filtered through this glass is transformed. It takes on a soft refractive glow.

Whiteley capitalizes on these qualities with a sleek minimal form and punctuating details.

Source: Richard Whitely "Blue Wedge." The Bullseye Connection Gallery.

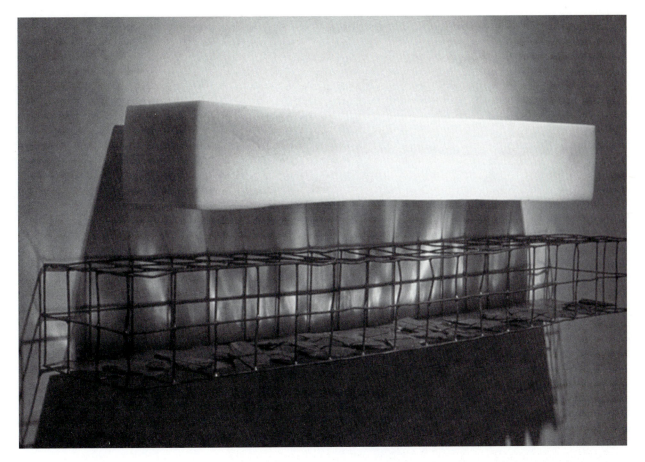

FIGURE 8–5 Thomas Skomski, ***Interminable.*** The lower half of Skomski's sculpture is a blackened steel cage, floored with a shiny copper sheet that *reflects* a strong, fiery color onto the wall. By placing shards of slate randomly over the copper, the sculptor breaks the reflected light into flames licking at the underside of a wax beam. The mass of wax seems about to succumb to the "heat" of this illusory fire.
Source: Courtesy of Thomas Skomski.

color, blue, correlates to smooth surfaces, and red, a more exciting color, to agitated surfaces.

TEXTURE AND VALUE

Unlike point, line plane, and volume which contribute more structured and *quantitative* aspects to form, color, and texture team up to add more *qualitative,* emotional aspects. Both the quantitative and the qualitative are needed for truly effective form.

The most visual—and measured—function of surface textures is their capacity for modulating *light value.* Light value is the measure of reflected light from a surface, the darkness or lightness of that surface. A white surface that is perfectly smooth will reflect its full whiteness. The more textured the surface, the more shadow is created and the less light is reflected. Rougher surfaces yield darker grays.

PROPERTIES OF MATERIAL

The cultural associations and visual characteristics of materials are crucial to the expressive richness of a form. The physical properties of

FIGURE 8–6 *Texture/Valve Samples.* Surface textures modulate the light hitting a sculpture and this can impart *coloristic* effects. One effect is the darkening value that the increase in minute shadows can cause. Another is the psychological difference between relatively placid and relatively agitated surfaces.

Source: Courtesy of the author.

FIGURE 8–7 Rob Lorenson, ***Shelter.*** Materials add both visual and *associative* qualities to a spatial form. The scrap tires, from which this sculpture was woven, add dense textural layers to a relatively simple form. The tire scraps also activate associations to automobile junkyards, a sharp contrast to the templelike image they form.

Source: Courtesy of Rob Lorenson.

materials, though, permit the actual realization of a form in space, that is, the capacity of materials to *acquire* and to *maintain* form in space.

Acquiring Form

A number of terms describe the capacity of a material to acquire form: *Plasticity* measures a material's ability to be worked into a new form; *elasticity* measures its tendency to return to its original form. Rubber bands are elastic because when stretched they will snap back into shape, while clay is plastic because when stretched it will hold its new shape.

Sculptors who are casting plaster are concerned with *viscosity,* i.e., how resistant to flow is the mixture with which they are working. A lower viscosity plaster mix will flow into areas of smaller detail. Woodworkers, on the other hand, may favor high viscosity glue that can be applied without dripping.

Machineability is the ease with which a material can be cut to shape. Machining is a sub-tractive process. Drilling, planing, sawing, chiseling, abrading, and the like are all examples of machining. All entail the use of a harder material whose edges to cut away a softer material.

Casting

Some materials will easily change from a liquid to a solid state. In that liquid state they can be poured to fill a negative form. Once solidified the material will have become a positive version of the negative. This is the process of *casting*.

The negative form may be built directly or it may be a *mold* taken from a positive original called a *pattern*. Expendable and easily shaped materials lend themselves to pattern making.

The liquid state of casting materials can harden by *evaporating, setting,* or *cooling.*

Many natural and synthetic resins can become liquid by dissolving. When the solvent evaporates the material returns to its original

FIGURE 8–8 Richard Rezac, **Veil.** Materials carry visual and psychological illusions, which can add strong levels of experience to relatively simple forms. In this case, the dense, industrial overtones of cast iron add an obdurate aggressiveness to its horn shape. The bit of dyed silk is in complete contrast, but gently and eloquently completes the form. The effect is balance and harmony, where opposites unite and resolve one another. Rezac drew his inspiration from warrior figures in Buddhist temples that worshippers had festooned with bright cloths.

Source: Courtesy of Richard Rezac.

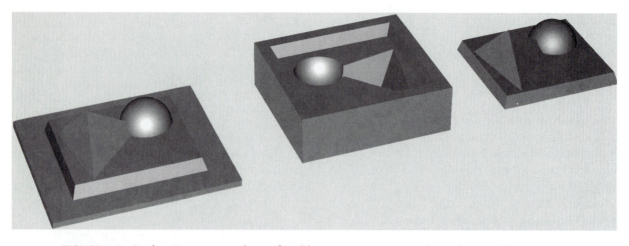

FIGURE 8–9 *Casting: Pattern, Negative, and Positive.* Casting is a commonly used process for making several replications of a single form. Its most important sculptural application, however, is to *translate* form from an easily worked and less "noble" material (e.g., plaster) to a more durable and/or expressively appropriate material (e.g., bronze). In the first case a durable *mold,* which will hold multiple castings, is necessary. In the latter case, a disposable mold, intended for one use, may be sufficient.
Source: Courtesy of the author.

solid state. Because the solvent is leaving the solution, the casting will shrink somewhat.

During setting a liquid mixture undergoes a chemical reaction, usually *catalyzing,* as with many plastics, or *hydration,* as with plaster and concrete. When plaster hydrates, water reacts chemically with the plaster powder to return it to its natural state as gypsum, a soft white rock. Setting gives off heat, which can cause burns when in contact with the skin.

Metals and some plastics melt when heated and harden when cooled. This process is also called *thermo-setting.*

STRENGTH

If a material is to maintain its form it must withstand the forces to which it will be subject. *Strength* measures this resistance to force.

The two major types of strengths of materials are *compressive strength* and *tensile strength,* which measures a material's resistance to *compression* and *tension.* Compression is a pushing force, while tension is a pulling force.

A material, like steel, with great compressive *and* tensile strength can be strong in virtu-

ally any geometrically stable pattern. Nicknamed "the mathematician's material," steel and its alloys are the materials most responsible for the incredible array of forms in modern art and design.

Steel boasts 70,000 to 130,000 lb. per square inch of both compressive and tensile strength. By contrast limestone, the most common building stone, commands a compressive strength of 2,000 to 14,000 lb. per square inch against a tensile strength of about 50 to 400 lb. per square inch. Manufactured from limestone, concrete features these same strengths. Masonry structures must therefore exploit structural forms that maximize compression and minimize tension. The most common device for this is the *arch.* Invented in the ancient Middle East, the arch re-distributes the compressive force induced by gravity to either side, thus permitting wide spans of space. Prior to the invention of the arch, stone's poor tensile strength prevented all but very narrow spans.

COMPOSITES

Two or more substances of differing strengths may merge to form *composite* materials with

FIGURE 8–10 *Structural failure in stone.*
Source: Courtesy of the author.

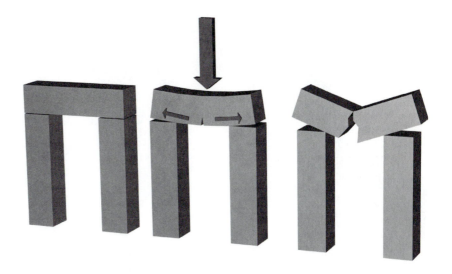

FIGURE 8–11 *Trilithons, Stonehenge.* The earliest architecture, like these stone spans from 1800 B.C.E., used a simple *post-and-lintel* construction. This method was limited to very narrow spans, because the lintel, or spanning stone, tended to crack under its own weight. As the span increased, so did the stones tendency to sag. Eventually the sag caused the stone to pull apart and crack from its underside.
Source: Courtesy of the author.

FIGURE 8–12 *Arch.* The *arch* eliminates the *tension* caused by sag and configures the stone to distribute its weight along lines of *compression.* As weight presses onto the center of the arch, the topmost stone, or *keystone,* acts as a wedge to direct the weight to the side. Each successive stone picks up the compression and continues to deflect it sideways until it meets the supporting wall. This wall is ordinarily fairly massive, as it must support all of the weight diverted by the arch's geometry.

Source: Courtesy of the author.

FIGURE 8–13 *Highway Overpass.* Concrete beams manifest the same strength as stone, but may be cast with steel rods embedded in them. This adds tensile *reinforcement* and enables the concrete to counter the tension brought on by sag. The result is the ability to span far greater distances, like those required of this highway overpass.

Source: Courtesy of the author.

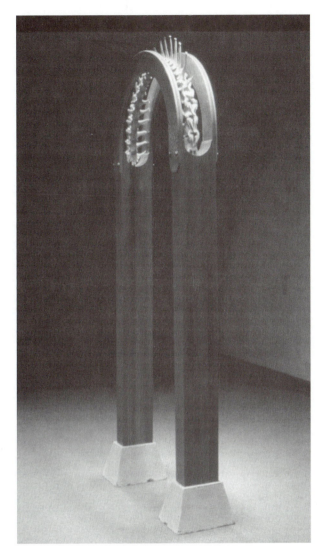

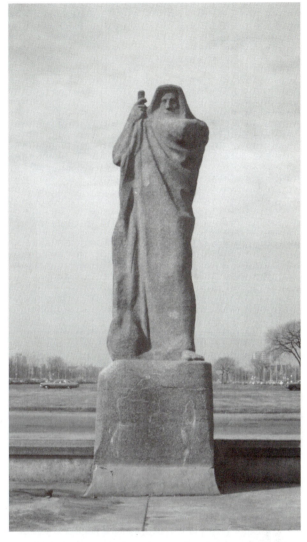

FIGURE 8–14 Mark Klassen, ***Support Structure.*** Materials can combine for both structural and symbolic ends. Concrete, bone, and wood are all structural materials, but can spark very different associations. Here concrete provides a sturdy architectural foundation, while the wood is crafted like fine church furniture. The deer spine, retrieved from a forest floor, revives its old role as a spanning structure, this time in a more geometric incarnation.

Source: Courtesy of Mark Klassen.

FIGURE 8–15 Loredo Taft, ***Time,*** from ***Fountain of Time.*** Taft's famous sculpture was fabricated in ferro-concrete, a technical innovation for sculpture at that time. An armature of dense steel mesh was impregnated and surfaced with a fine aggregate concrete. The resulting sculpture was light, since it garnered great strength from a thin, composite shell. After 80 years this sculpture is in dire need of renovation.

Source: Courtesy of the author.

characteristics of both of the original substances.

The most common method of creating composites is *reinforcing.* Reinforcing introduces a material known for its tensile strength into a material characterized by compressive strength to produce a composite with both strengths. Classic examples are horsehair or sisal fibers mixed into plaster, or *ferro-concrete,* concrete impregnated with wire mesh.

One of the most dramatic examples of composite construction is the *reinforced shell:* very

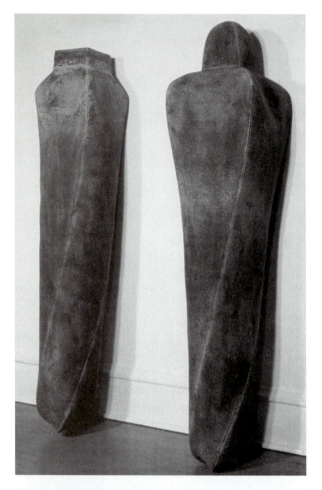

FIGURE 8–16 Joan Livingstone, **Dyads.** In Livingstone's work industrial felt provided the tensile fiber and epoxy resin contributes rigidity and compressive strength. The hollow, half architectural, half organic character of the two-part sculpture comes to the fore due to its unusual composition of materials. These are like sewn sepulchers.
Source: Courtesy of the private collection of Joan Livingstone.

strong thin curving spans that can enclose large interior volumes. During World War II, Italy constructed ferro-concrete battleships. Cannon projectiles reportedly bounced off their hulls.

A major purpose of composites is to develop materials with a high strength-to-weight ratio. Fiberglass canoes, graphite golf clubs, and even the foam board used in white models are composites. Today, materials scientists are working at the molecular level to create an entirely new generation of composites.

CHAPTER 9

Structure

INTRODUCTION

Structure is the physical organization of an object in space. Structure imparts *stability* and *viability* to the object: its ability to meet its physical parameters. Visual qualities are not divorced from structural realities. The visual distinction between organic and geometric form is also a distinction between different structural needs.

Highly efficient structures will frequently evince their own visual elegance. However, good three-dimensional design often asks that physical structure adapt to the aesthetic and expressive goals of a design. Visual dynamism and structural stability must then come to terms. In such cases, the limiting factor is always physical: compositional freedom extends only as far as the requirements of stability will allow. Stability is a relative term. Stability for a jellyfish is very different from stability for a skyscraper. Like visual organization, structure emerges from the design goals of the object.

In a world where gravity holds sway, a structure is unstable if it is prone to topple over or to collapse. Stability is defined by two chief characteristics: *resistance to deformation* under force to prevent collapse and *secure balance* to prevent toppling.

FORCE AND STRUCTURE

Unlike jellyfish and like the skyscraper, most structure is designed to resist the force of gravity. *Exo-skeletons* provide this support external-

ly. A shell is an exo-skeleton. People, however, have *endo-skeletons,* an internal armature that supports our muscles and organs.

More complex forces than the downward pull of gravity commonly buffet structures. In addition to the forces of *compression* and *tension* discussed in the previous chapter, good structures must resist *bending, shear,* and *torque* forces as well. The weight of a human body on a chair, for instance, will exert compression and reciprocal tension on the chair's parts. However, human beings are not static weights. They will twist and shift and thus exert bending, shear, and torque that the chair must withstand.

Bending results when compression is deflected sideways in a structural unit. The material on the inside of the bend compresses while material on the outside tenses. Bending restricts the length of an element under compression relative to its thickness.

Shear occurs when structural members push sideways in opposing directions. The structural material must be able to resist tearing at the point of shear, usually at the joint where members meet.

Torque is a twisting force related to shear. When a screw is tightened too much, its head may shear off due to excessive torque.

STRUCTURAL CONFIGURATIONS

Only one linear shape, the triangle, resists deformation against force. All other shapes will distort unless they are *braced* by triangles.

93

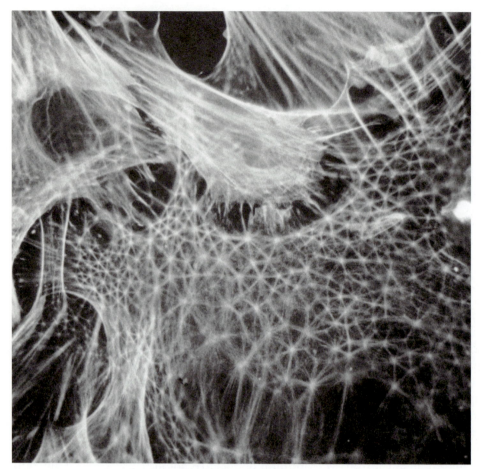

FIGURE 9–1 Kate Mobes and Alan Hall. ***Geodesic Form: Cytoskeleton of a Mammalian Cell.*** Peering into the smallest level of biological form, all of the most sophisticated structural principles discussed in this chapter become evident. A complex *truss work* arranged in a flexible *geodesic* web supports our cells. The combination of flexibility and support is an attribute of nature's control of *tensegrity.*

Today the most cutting edge research into structure seeks to duplicate nature's success at creating light, movable frames within man-made structures. Applications range from space stations to earthquake proofing to robotics.

Source: Courtesy of Kate Nobes and Alan Hall. Originally appeared in *Scientific American,* January 1998, p. 54.

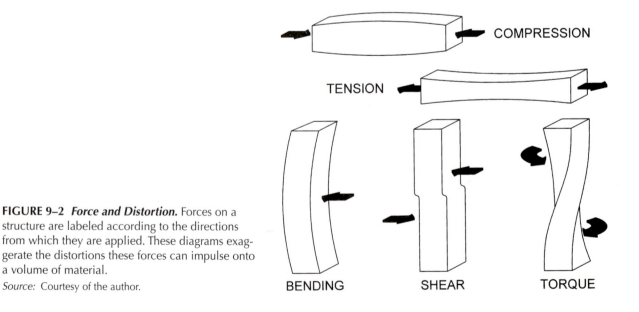

FIGURE 9–2 *Force and Distortion.* Forces on a structure are labeled according to the directions from which they are applied. These diagrams exaggerate the distortions these forces can impulse onto a volume of material.

Source: Courtesy of the author.

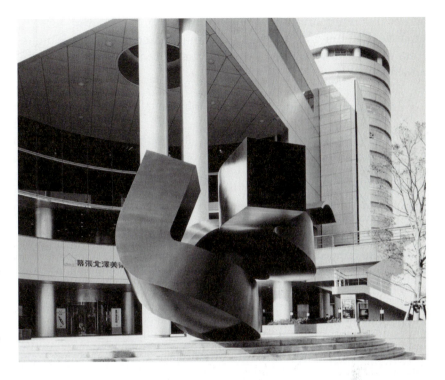

FIGURE 9–3 Clement Meadmore, ***Janus,*** 1979. A sculptor can impart suppleness and liveliness of form by portraying the illusion of applied force. Meadmore has created an ongoing body of work dedicated solely to the transformation of massive rectangular beams into poised, active entities by means of such illusions.

Source: Courtesy of Clement Meadmore, "Janus." Photo by Osamu Murai. CSC Contemporary Sculpture Center Co., Ltd.

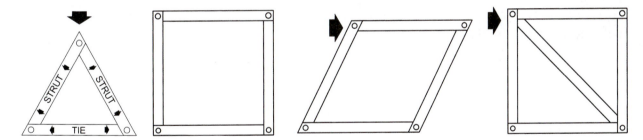

FIGURE 9–4 ***Diagrams: triangulation and force.*** Materials like wood and steel are strong under both tension and compression. As a result they can configure into stable triangular configurations, where linear elements must exchange roles as *struts* and *ties* depending on the direction of force. Other configurations, like squares, can be stable only when *braced* into triangulated parts.

Source: Courtesy of the author.

Trusses

Trusses are linear structures composed of triangles. The gables of most homes take their shape from the truss work supporting the roof.

The simplest truss is a single triangle. A weight mounted at the top of this triangle will simultaneously compress its sides and direct

force outward. This in turn will pull the base outward, placing it under tension.

Structural members that resist compression (like the sides of the triangle) are called *struts*. Those that resist tension (like the base of the triangle) are *ties*. Every member of a truss is either a strut or a tie. Depending on the direction from which force is applied, a

structural member may serve as either a strut or a tie. This is why trusses are constructed from materials with good compressive *and* tensile strength.

Distributing Force

Every trusslike structure requires a reciprocal interplay of tension and compression to maintain stability. When it is possible to maintain a consistent distribution of tension and compression within such a structure, then it is also possible to use very flexible, high-tensile materials as ties.

In these structures, materials like cable, wire, rope, or cord remain stable and strong because they are always pulled taut. The virtue of using such thin strong ties is structural efficiency. Weight is greatly reduced without lessening strength.

One method of distributing force is to *prestress* the tie lines so that they will remain under tension and keep the rigid members of the structure under compression. Most tents stand up due to this principle. *Guy* lines tightened and staked to the ground transfer compression to the tent poles. Tent pole plus guy plus ground configure the stable form of a triangle. This configuration, however, demands *counterforce,* other guy lines working against the pull of the original guy line, to keep the pole from toppling. The principle of *force–counterforce* is an effective device to maintain stability.

FIGURE 9–5 Skidmore, Owings, & Merrill, *John Hancock Building,* 1965–1970. One of the world's tallest buildings gains the stability to withstand Chicago's strong prairie winds by means of a series of giant crossed ties.
Source: Photo courtesy of the author.

FIGURE 9–6 *Traditional water tower.* The Hancock architects borrowed from the vernacular structure of standard water towers. Note how the ties, which never come under compression, are reduced to thin rods of steel. By contrast the struts are thick beams, especially the vertical struts that must support the weight of a full tank of water.

Source: Courtesy of the author.

FIGURE 9–7 *Mast & guys.* Taut *guys* hold the masts of sailboats stable and erect. Affixed to the deck and the top of the mast a guy forms a stable triangle. Without the counterforce of an opposing guy, however, the mast would topple. Note how the cross arm, too, is braced under tension.

Source: Courtesy of the author.

Tensegrity

Tensegrity (tension + integrity) is a method for using only lines of tension to support a structure.

In true tensegrity, struts are never in contact with one another, but suspend with the force of tension. The structures defy common sense. With no rigid units in contact, they nevertheless are strong and stable.

By selectively tensing and relaxing ties a tensegrity structure can flex and shift its configuration in space. We do this when our muscles tense and relax and allow our bones and bodies to move.

LINES OF FORCE

Geodesics

Geodesics are structural lines that lie on a great circle of a sphere. A great circle is the largest circle that can be drawn on the surface

FIGURE 9–8 Kenneth Snelson, ***Needle Tower,*** 1968. As a student sculptor, Snelson discovered the principle of tensegrity—a term coined by Buckminster Fuller. Snelson remains the principle practitioner of this structural principle. His sculptures seem to almost levitate and to reveal a strength and drama that defy our intuitions about structure.

Source: Courtesy of Kenneth Snelson.

FIGURE 9–9 *Tensegrity octet.* This octet is the basic unit of a tensegrity structure. An octet truss groups triangles in the form of an octahedron. In this octet, the edges of the octahedron are the tension lines, and the three compression units, running at 90° to one another, are its axes. Snelson's sculpture uses this basic form but separates the struts, so that they seem to float freely.

Source: Courtesy of the author.

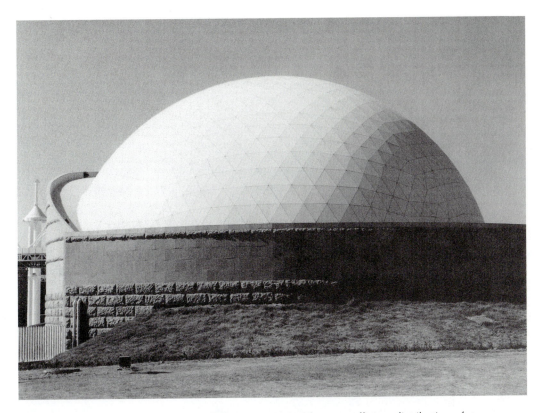

FIGURE 9–10 Geometrica, Inc., ***Geodesic Dome,*** 1996. The most efficient distribution of stress on a sphere is along geodesic lines. These are any lines that lie on a great circle of the sphere. When measured against the domes of ancient Rome, geodesic domes are 20 times lighter. Prior to geodesic technology the largest dome, the Pantheon, spanned 144 feet. New domes have spanned up to 1,000 feet. *Source:* Courtesy of Geometrica, Inc., Houston, TX.

of a sphere. The lines of force on a spherical surface tend to follow along great circles. The noted structural geometrician, Buckminster Fuller, grasped the potential of this principle for constructing domes.

A number of great circles can crisscross into a spherical web of triangles. If the arc segments forming the individual triangles are replaced with straight structural members, a geodesic structure results. This is the basis for the geodesic dome: an elegant and extremely strong truss work defining the spherical curvature of the dome.

Catenaries

One thing that biomorphic structures demonstrate is that paths of stress and force rarely, if ever, fall along straight lines. A clear demonstration of this principle is to hang a chain from two hooks on the ceiling. It will droop in a precise symmetric curve called a *catenary* (from the Latin for chain) that is determined by the pull of gravity distributed evenly along its length. If a catenary is inverted it will form an arch stronger than the classic semicircle. Formed by the pull of gravity, it is also the most efficient shape to resist the push of gravity. The great French engineer Louis Eiffel combined steel trusses with the curve of a catenary to establish the profile of his famous tower.

The standard catenary is especially efficient at handling stresses spread evenly along its curve. In some cases, such as bridge construction, the arch must support weight

FIGURE 9–11 *Catenary Diagrams.*
Nineteenth-century engineers planned *catenary* arches by hanging weights from ropes and placing the weights according to weight distributions the future arch would need to meet. The first diagram (top left) depicts weight distributed at equal distances along the arch. The second (bottom left) pictures weights placed at equal distances across the horizontal span of the arch. This arch follows a *parabolic* path. The image to the right delineates the profile curve of the Eiffel Tower. One of the great engineers of his time, Louis Eiffel elected to use a catenary curve to integrate strength and elegance.
Source: Courtesy of the author.

FIGURE 9–12 *Parabolic arch-bridge.* The horizontal roadway of this bridge suspends from arches at equal points along its span. The most efficient arch, then, is an inversion of the parabola in the second diagram above. Note how the bridge's arches echo the hanging chains, which connect concrete stanchions lining the Chicago River.
Source: Courtesy of the author.

FIGURE 9–13 Geometrica, Inc. *Freedom Structure Dome,* 1997. The science and art of distributing force on shell structures has been significantly amplified through computers. Here the computer adapted the form of the dome to cover a rectangular factory floor of nearly 200,000 square feet. The software for this system can generate dome configurations for almost any floor plan.
Source: Courtesy of Geometrica, Inc., Houston, TX.

distributed horizontally across its span, and a variant type, the *parabolic arch,* works better.

SURFACE STRUCTURES

Geodesic domes integrate the truss configuration onto a hemispherical surface. The geodesic dome might be considered a linear rendering of a shell structure.

Shells

Shells are rigid exo-skeletons, which gain their strength by virtue of their *double curvature.* A double-curved surface arcs simultaneously in two directions of space. Domes, eggs, saddles, and boat hulls exemplify double curvature. Cones and cylinders demonstrate single curvature.

Domes and eggs both evince *positive curvature,* that is, all areas of their surface are convex. Saddle curves traverse smoothly between areas of positive and *negative curvature.* Composite materials develop remarkable strength when configured into shell structures. Domes built of ferro-concrete cover entire stadiums and fiber-resin is a preferred material in recreational boat hulls.

Tensile Surfaces

Tensile surfaces (also called *membrane structures)* employ fabric pulled taut against

FIGURE 9–14 *Paraboloid shell.* Prior to the development of engineering on the computer, popular configurations for *ferro-concrete* shells were often based on parabolic and hyperbolic curves. Since such surfaces can generate from straight lines, builders could both define and reinforce the shell with a series of taut steel cables. By contrast to the domes in Figure 9–13, far less calculation was necessary to achieve a dramatic span. *Source:* Courtesy of the author.

compression members. They are, in other words, tents. The most intriguing of these are a far cry from the tents of one's scouting days, and derive their shape from the geometry of *minimal surfaces.*

Sometimes called "soap bubble" geometry, this branch of engineering studies the forms that surfaces (like soap films) naturally take under tension. Equal tension in all directions yields a simple sphere, but under opposing tensions the results are strikingly elegant surfaces of positive-negative curvature. These curvatures follow the arcs of catenaries, hyperbolas, and other similar curves (Figure 9–14).

MODULAR STRUCTURE

Modular structure is an outgrowth of mass production in the twentieth century. With modular construction the parts of a structure can be mass produced at a factory and assembled on site.

Structural systems are modular, meaning that they are made up of the exact same element, or limited set of elements, used over and

over. Structural systems have three requirements: repeating structural units (modules), along with a repeating joining system, and a systematic pattern of arrangement.

Geodesic domes are highly systematic structures. Only three or four different struts and one or two joint arrangements are repeated in building a typical dome. *Space grids* are structural systems that take the form of geometric, space-filling lattices.

Fully modular design allows the same module or limited set of modules to be deployed in multiple patterns, thus imparting a simple set of units with the flexibility to adjust to different situations. The character of a modular design depends on: (1) the form of the individual modules, (2) the *frequency* or number of modules used, and (2) the arrangement of the modules.

JOINING

No matter how strong a structure's members or how efficient their distribution the structure will fail without proper joining. The strength

FIGURE 9–15 Skidmore, Owings, and Merrill, *Haj Terminal,* 1982. New and very strong synthetic fibers have enabled the development of exceptionally strong and weatherproof fabrics. Architects can now design buildings formed from fabric held under tension. Such structures, essentially large permanent tents, play well in Arab lands, where tents once constituted the traditional domiciles of a nomadic people. This airport, built outside of Jeddah, Saudi Arabia, is at this writing, the world's largest membrane structure. The tents house up to 80,000 pilgrims to Mecca. Pilgrims may cook over fire pits and camp for up to 36 hours while visiting Mecca.

Source: Courtesy of Image Source, Inc./Jay Langlors.

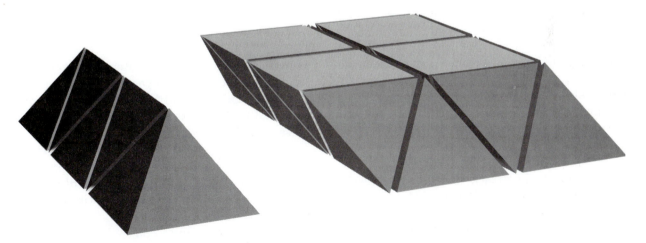

FIGURE 9–16 *Space packing.* Space frame geometry creates a triangular lattice of space filling cells. Both the traditional cubic grid and the space frame are modular; that is, they can grow from units of equal length and with the same repeated joint. The cubic grid efficiently encloses office and living space, while the space frame, with its array of tetrahedral and pyramidal cells, displays far more structural strength.

Source: Courtesy of the author.

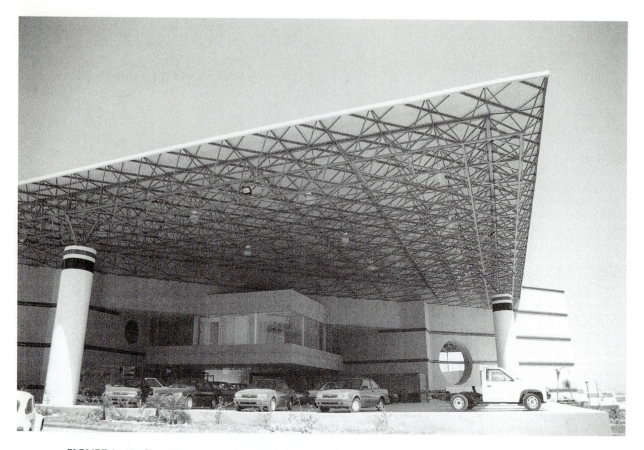

FIGURE 9–17 Geometrica, Inc., ***Awning, Nissan Cumbres Agency,*** 1995. Space frames can achieve dramatic *cantilevers* and surprisingly broad spans—up to 200 feet between supports. This pavilion for a car dealership demonstrates both of these capabilities. If the space frame is arched (see Figure 9–13), the span can increase fivefold.
Source: Courtesy of Geometrica, Inc., Houston, TX.

and design of joints is as important as the structural members. In some ways joints bear the brunt of greater forces. Shear, for example, occurs primarily at a joint.

Attachment

Parts can be attached through *adhesion, fusion,* or *mechanical fastening.*

Adhesion is simply gluing parts together. Less simply it is the process of joining two materials with a third adhesive material between them. An adhesive's material properties must be compatible with their use and with the other materials. Adhesives may form a physical and/or

a chemical bond with the material. Porous materials like paper or wood permit the adhesive to penetrate and physically interlock with the material. Glue that joins nonporous materials like glass employs a chemical bond.

Fusion joins by integrating the material of one part with that of another. Welding is a fusion process: parts are melted (in welding metals) or dissolved (in welding plastic) at their point of juncture and allowed to flow together and solidify into a united piece.

Mechanical fastening uses an intermediate mechanical part to hold the attached parts. Simple nails and screws are mechanical fasteners, as are hinges, lashings, and sewing thread. The

FIGURE 9–18 Geometrica, Inc. **Geodesic Dome construction.** Geometrica markets its structures to parts of the globe with growing economies, but with few skilled technicians. Modular design enables easy assembly by unskilled workers from simple mass-produced parts.
Source: Courtesy of Geometrica, Inc., Houston, TX.

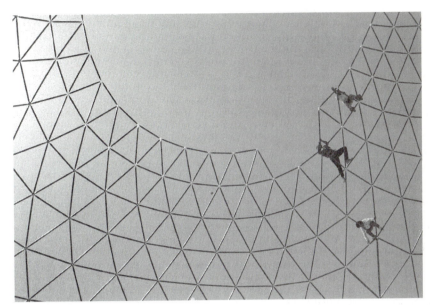

mating parts may also be shaped so the two parts mechanically interlock. Designing and crafting such joints is a major part of the art of woodworking.

Fit

Accurate and precise fitting is necessary for viable structures.

Accuracy, precision, and *fit* are all related and should be understood in reference to one another. Since no fit can be perfect, some allowances must be made for the two parts to slip together with the male slightly smaller than the female. For *precision* fits this allowance or *tolerance* is very small, as in a fine watch. The greater the tolerance the less precise is the fit.

An *accurate* fit lies within the limit of tolerance. Thus if two parts must fit together with a tolerance of +/-¹⁄₁₆" the fit would be accurate if no gaps greater than ¹⁄₁₆" existed between the two parts. A ¹⁄₁₆" tolerance requires a more precise fit than a ¼" tolerance. The former tolerance is about right for most problems executed in a beginning design class; the latter is about right for rough carpentry.

FIGURE 9–19 *Space frame joint.* The joining system of a structure must assure strength equal to the carrying weight of the structure and accuracy in the geometric alignments. The inventor of the space frame, Alexander Graham Bell, devised a joint in the shape of a cuboctahedron (see Chapter 6) to accommodate skew angles of its members. Many of today's commercially available designs closely adhere to Bell's original concept.
Source: Courtesy of the author.

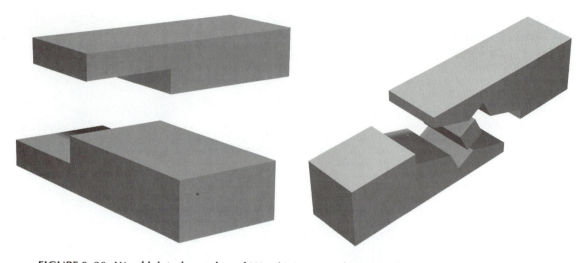

FIGURE 9–20 *Wood joints: lap and scarf.* Wood joinery combines *mechanical* fastening with *adhesion.* The joints are mated with positive–negative interlocks and adhered with glue that penetrates the wood fibers. Joint design is an exceptionally sophisticated aspect of woodworking. The joint to the left, a lap joint, is one of the simplest for joining at a corner. The scarf joint at the right is more sophisticated. Designed by Japanese carpenters to splice short beams for larger spans and taller supports, this joint will resist tension and compression directed along the length of the beam.
Source: Courtesy of the author.

SECURE BALANCE

Balance in three dimensions is both visual and actual. In the course of achieving an interesting visual balance, the designer must ensure that the requisites of physical balance are met.

Center of Gravity

The center of gravity is the point around which the weight of a structure is evenly distributed. It lies on the structure's *vertical axis,* the plumb line around which gravity exerts equal pull. A high center of gravity will make the structure top heavy and likely to tip over, while a low center of gravity will anchor it to the ground. This center of gravity must lie above the area defined by a structure's base. The closer this center is to the center of the base the more stable is the structure.

Tri-podal Base

While it is mathematically possible to balance a pin on its tip or a razor blade on its edge,

it can never practically happen. A base is needed. The broader the base, the greater its stability.

The corners of a triangle comprise the least number of points to define a flat shape, or plane. As a result, as few as three points of contact, properly distributed, will create a stable base, although more feet are usually desirable, as with tables and chairs. Three feet work better on uneven surfaces than any other configuration. This is why tripods are used to support cameras and surveying instruments on irregular terrain.

HIERARCHICAL STRUCTURE

Hierarchical structure is a multileveled system for assembling a large number of simple elements into a higher complex structure. Hierarchical structure groups simple elements into small structures, which gather together into larger structures, and which in their turn congregate into yet larger structures, and so on.

Nature loves hierarchy. Look at our bodies. Nature has built them from organs, organs from

FIGURE 9–21 Jerry Peart, ***Blue Geisha,*** 1985. Often the challenge to a designer or sculptor is to integrate structural stability with free and dynamic form. Peart is a master of this integration. His forms dip and swirl and dance through space: all the while honoring their *gravitational center.* In this sculpture, Peart holds the points in contact with the ground to the necessary minimum of three.

The accompanying diagram demonstrates that these points and the center of gravity form a stable tetrahedron.

Source: Courtesy of Jerry Peart.

cells, cells from organelles, organelles from molecules, and molecules from atoms.

A common type of hierarchical structure called a *self-iterating structure* is much scrutinized by form theorists today. In such a structure, each level of the structural hierarchy repeats, or iterates, the pattern of the whole. The study of self-iterating structures that continue indefinitely is a branch of the science of *fractals.*

Statistical Structure

Randomness can be as much a feature of a physical structure as it can be of a visual struc-ture. Self-iteration, for instance, often plays out as *statistical structures.* The term statistical denotes the fact that the elements in the structure repeat with random variations within certain limits.

Good examples of statistical structures are *branching structures.* Within a single species of trees no two branch in exactly the same way. Yet all elm trees still look sufficiently alike so that an experienced arborist can spot a stray elm in a grove of oaks, even in winter. The random branching of individual trees does not vary enough from the norm of the species to dramatically change their overall appearance.

FIGURE 9–22 *Grand Canyon.* Over eons the Colorado River has etched deeply into the slowly rising Kaibab Plateau. As this satellite photo illustrates, smaller feeder streams cut their own canyons, from which branched deep ravines. Rivulets enter gullies, which in turn cascade into the ravines. Each diminishing engraving of the plateau is a smaller mirror of the larger canyon. Note how the enlarged detail reveals smaller and smaller branches in one of nature's classic *fractal* patterns.

Source: Courtesy of NASA Headquarters. Highlighting and image editing by the author.

Chaotic Structure

Chaotic structures are self-iterating forms found in turbulent matter. They manifest even less predictability than more static statistical structures. The patterns, nevertheless, can be distinctive. Clouds driven by the wind or eddies stirred by a flowing brook exhibit the turbulently random, but distinctive, structuring that scientists call *chaos*. In the physicist's notion of chaos, self-iterating patterns manifest themselves in deeper and less apparent arrangements of

FIGURE 9–23 Chaim Goodman-Strauss, ***Dodecafoam,*** 1995. Fractal patterns are very simple in their base structure, but evolve great complexity in their continual repetition. Most fractal forms are computer generated, due to the computer's tireless capacity to churn out repetitious tasks. Goodman-Strauss generated this fractal by instructing the computer to stack a spire of proportionally smaller dodecahedrons on each face of a core dodecahedron. He further instructed the machine to fit more of the same volumes into the crannies of each spire, and then to continually fill the smaller and smaller crannies with smaller and smaller dodecahedrons. Fractal solids such as this are called *fractal foams.*
Source: Courtesy of Chaim Goodman-Strauss.

FIGURE 9–24 J. Hester and P. Scowen (Arizona State University), ***Gaseous Pillars, M–16 Galaxy.*** Ancient peoples saw the heavens as structured in the perfect geometry of circles and spheres. Recent images of space, like these captured by NASA's Hubble telescope, offer a universe structured as well by extreme turbulence. Here a gaseous region sprouts huge columns of gas. From these columns bud smaller columns, surmounted in turn by the beginnings of yet smaller protuberances. Smallest of all are fingers of gas whose rounded tips are actually globules breaking away to become future stars. Chaotic structures are iterative, a looser version of fractal structures.
Source: NASA Headquarters. hotos created with support of Space Telescope Science Institute, operated by the Association of Universities for Research in Astronomy, Inc., from NASA contract NAS5–26555. Reproduced with permission

FIGURE 9–25 Bruce White, ***Planetary Void,*** 1995. White meticulously cut thousands of perforations in two 4-foot aluminum bowls and sandwiched these between circular rims. The sculpture juxtaposes ancient and contemporary ideas about astronomical structure. The ideal spherical volumes and circular lines of the ancient universe erode in a chaotic pattern.
Source: Courtesy of Bruce White.

forms. The froth on the crest of a wave, for example, is a turbulent pattern of wavelets within wavelets.

Fractals and chaos also structure the micro-universe inside our bodies. Arteries, veins, and capillaries lace muscles and organs with fractals branching as do the tubes and air sacs of lungs. Contrary to expectations, the unique structures of chaos harmonize the beats of our hearts and the flow of our thoughts.

CHAPTER *10*

Time and Kinetics

INTRODUCTION

Time imposes itself on the structure of objects just as surely as do the spatial dimensions. Every object endures, changes, or performs in space. Endurance, change, and performance all occur through time.

Time, Change, and Motion

Time is change. The changing position of the sun indicates the procession of the day; growing bodies mark the progress from child to adult. Durable things change slowly; ephemera come and go quickly. The patterns of time are patterns of change.

The most pervasive perception of change is the perception of motion. In the strictest physical sense, all change is motion. The molecules of a rusting junk heap, for example, are in constant motion. They interact with the oxygen in the air, separate from their iron bonds, and crumble into the soil.

The previous chapters looked at three-dimensional structures as if they were active in space but frozen, or static, in time. Visual qualities, such as flowing lines or dynamic composition, imply motion, but do not actually move. Sculptures, crafted in durable stone or bronze, traditionally portrayed *illusory motion*. Just as painters for centuries created the illusion of a third-dimension, so sculptors created the illusion of the fourth dimension of time.

Some twentieth-century sculptors, who chafed at this tradition of "frozen motion," sought to create works that were *dynamic* in time. Their constructions are known as kinetic sculptures because their designs incorporated patterns of real movement. In short order, mechanized and motorized sculpture, followed more recently by electronic and digital controls, greatly increased the complexity and sophistication of this art form. Time, through actual motion, had become a literal and intrinsic element of sculpture. Design of objects began to focus on the structure of their temporal dimension.

PATTERNS IN TIME

Living on earth and living as humans disposes us to experience time as both cyclic and linear phenomena.

Cyclic Time, Rotary Motion

The recurring cycle of day into night and the annual return of the seasons establish the daily and yearly governance of our lives. Plants and animals—including us—develop biological rhythms called *circadian* ("around the day") rhythms that follow a 24-hour cycle.

Circular or *rotary motion,* such as the turning of the earth on its axis, determines the repetitious and rhythmic nature of cyclic time. Like a turning wheel, rotary motion regularly returns

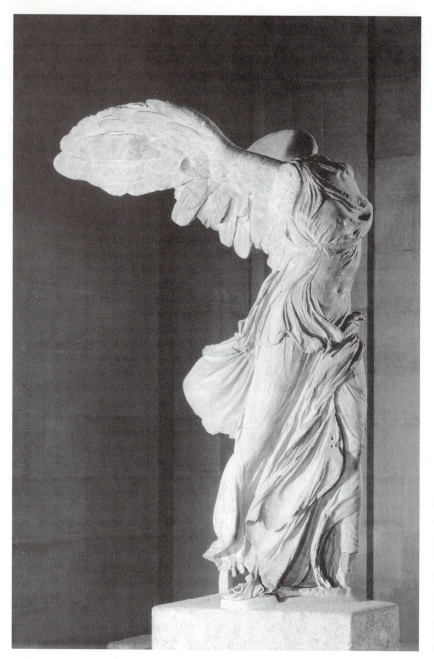

FIGURE 10–1 Pythocritus, ***Victoire de Samothrace,*** 190 B.C.E. The Greek goddess of victory sweeps down from the sky onto the prow of a ship. The instant of her swift alighting has been preserved in the *implied movement* of her marble robes for over 2,000 years.

Source: "Victoire de Samothrace," courtesy of the Musee du Louvre, Paris. Photo © RMN.

to a previous point in its cycle. Consequently, objects driven by rotary motion are structured in time by repetition.

In the early Industrial Revolution, the motion of water-powered wheels were translated into the regular repeatable movements required for mass production. Later motors took over, but the repetition remained and factory work be-

came synonymous with tedium. In the aesthetics of time as of space, variety is needed to spice things up.

Linear Time, Events

Despite the repetition of days and years, the overall direction of human life is linear. Be-

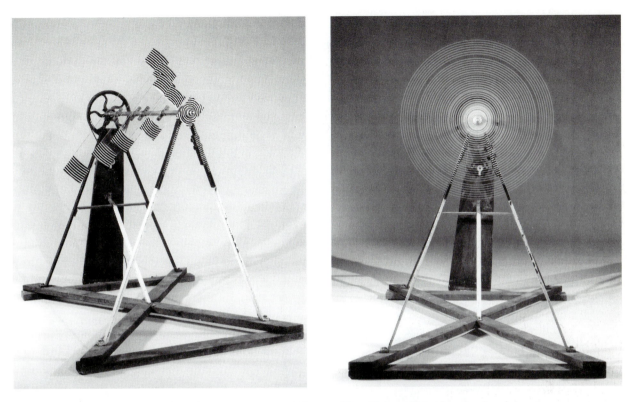

FIGURE 10–2 Marcel Duchamp (1887–1969), ***Rotary Glass Plates,*** 1920. Motorized sculpture appeared early in the twentieth century and became a mark of the new and rapid changes effected by technology. Duchamp displayed his characteristic irony when he designed this sculpture to appear as a single static image of concentric circles when it was in motion.

Source: Marcel Duchamp, "Rotary Glass Plates" (Precision Optics), two views. Photos courtesy of the Yale University Art Gallery. Gift of Collection Societe Anonyme.

ginning at birth, life follows an inexorable path through growth, maturity, and decline. *Linear time* is just such a progression, a trail dotted with events of which none is quite like any preceding. Time, as we live it, is a rich meshing of cyclic and linear patterns, of repetition and surprise. Both cyclic and linear time would drag on with the dullness of an empty room were not events to fill them. Much as forms and shape enliven space, so *events* steer and activate the experience of time.

Duration and Rate

Events have a magnitude known as *duration.* Events filling more time loom larger than those passing quickly. To help hold the viewer's attention, a designer can vary the duration of the *pauses* and *actions* that constitute an event.

Pauses, periods of inactivity, function in the structuring of time as surely as the periods of action. Pauses can be likened to the negative forms of spatial compositions. They space out actions in time and are, thus, essential to the pace and rhythm of temporal patterns.

Events proceed at a relative pace of change known as *rate.* Change can happen swiftly or slowly; its rate can speed up or slow down. *Acceleration* and *deceleration* measure how quickly an event increases or decreases in its rate of change. Both duration and rate can fluctuate in a *rhythmic* manner, characterized by regular occurrences as with cyclic time, or in a *sporadic* manner, characterized by scattered occurrences as with linear time.

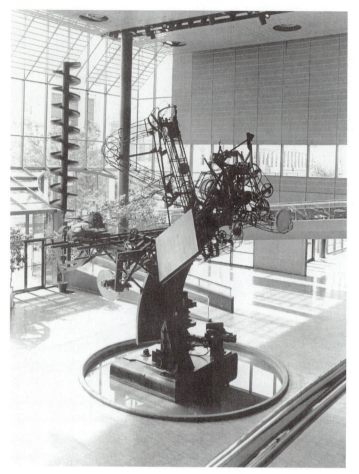

FIGURE 10–3 Yves Tinguely, *Chaos I,* 1974. A bizarre amalgam of scrapped machine parts functions as a most unusual public clock in downtown Columbus, Indiana. Depending on the hour, one to twelve battered steel spheres *accelerate* down a wire maze to the base of the contraption. Though the clock maintains a 12-hour *cycle,* Tinguely has replaced the steady movement of hands with long *pauses* punctuated by progressively longer periods of *action.*
Source: Photo courtesy of Balthazar Korab Ltd.

OPERATORS AND OPERATIONS

A kinetic object can depend on the regularity of its own mechanical operation or rely on the occasional participation of an operator to initiate change. Objects designed to work through an operator are shaped in space and time by two factors: (1) the likely behavior of the operator and (2) the range of motions made possible by the physical design of the object. Operators need not be human. Wind and water can be operators. Objects as different as wind chimes and automobiles require operators.

An operator may be another kinetic object. The idea of machines operating machines is widespread in today's factories. Programmable machines, or *robots,* built to operate other tools and machines are fundamentally changing the nature of factory production.

Going a step further, researchers in the developing field of *artificial life* are inventing mechanisms, which are adaptable and self-operating. They direct their own change. Essential to life is its ability to self-operate.

MEDIUM AND MOTION

In addition to the behavior of the operator and the physical mechanics of the kinetic object, a designer often needs to consider the *medium* through which an object will move. The most common such media are air and water.

Just as many of nature's most elegant life forms derive from streamlining for movement through a medium, so do some of humankind's earliest and most intriguing inventions. Kayaks and canoes, sails and hulls, kites and boomerangs

FIGURE 10–4 Dean Langworthy, ***Allegory Engine,*** 1981. This towering bin is filled with sand that can be drained by opening a spigot at its base. As the level of sand lowers, so does a heavy weight that, by means of a system of pulleys, turns the wheels and drives the tower forward. Since it relies on the whim of passing viewers to turn on the spigot, *Engine* inches forward only *sporadically.* Its periods of *pause* and *action* are largely unpredictable, although its deliberate forward movement is not. Slowly the sand runs out, exhausting the life of the sculpture and leaving only a spoor of sand to mark its progress.

Source: Courtesy of Dean Langworthy.

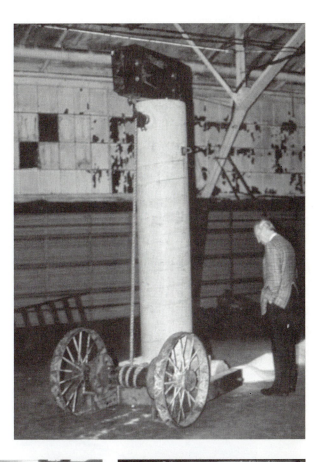

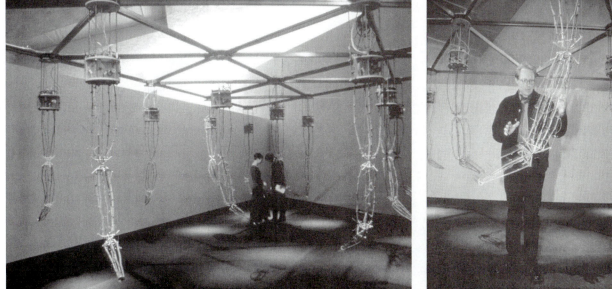

FIGURE 10–5 Kenneth Rinaldo, ***Autopoesis,*** 2000. Who's operating whom? Photoelectronics and programmable circuitry elicits responses to the movement of the viewer. The responses of one unit of this sculpture trigger yet other responses from its fourteen companions. The instigating unit then, in turn, responds to the movements of the others. The resulting intermachine reactions exhibit a group personality of sorts, which in turn elicits behaviors from the viewer. The effect is eerily lifelike.

Source: Courtesy of Ken Rinaldo, Emergent Systems: © Photo Pirje Mykknen, The Central Art Archives, Helsinki (left). © Photo Yehia Eweis, Kuvataiteen Keskusarkisto/The Central Art Archives, Helsinki (right).

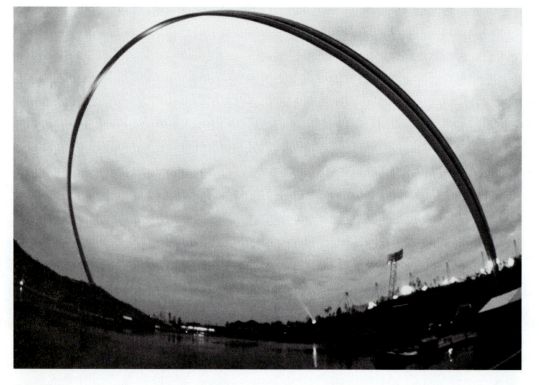

FIGURE 10–6 *Boomerangs.* Moving through air and harnessing air: the Native Australian boomerangs' airfoil provides the lift to hurl them long distances across open plains. Their overall shape adapts to the environment and specific use. Hunting boomerangs, designed for longer, more accurate trajectories, are larger, thicker, and heavier, with a broad angle. Natives living in marshy regions developed the returning "V" boomerang. Its spin imitated the flutter of a hawk's wings and so startled game birds into the hunters' nets. The hook boomerang doubled as a war club.

Boomerangs were cut from the crooks of carefully chosen tree branches, so that the grain of the wood would follow the curve of its design.

Source: Courtesy of the author.

FIGURE 10–7 Otto Piene, ***Olympic Rainbow,*** 1972. Inflated with helium, Piene's sculpture could arc and twine over far greater distance than could a heavier-than-air structure. It formed a colorful, fluctuating line over the closing ceremonies of the 1972 Olympics.

Source: Courtesy of Otto Piene. Photo by Wolf Huber.

FIGURE 10–8
Hans Haacke,
Condensation Cube,
1963–1965.

Source: Hans Haacke, Condensation Cube," V. 12 x 12 x 12" (30 x 30 x 30 cm), acrylic plastic, water, climate in area of display. Courtesy of Hans Haacke. © Hans Haacke/VG Bild-Kunst/Artist Rights Society (ARS), NY.

are among the most common and elegant responses to dealing with movement using air and water.

Air and water can themselves be formed by the three-dimensional designer. An ordinary balloon, for instance, is simply air compressed into a closed rubber surface. Replace the air with a lighter gas like helium, and the inventive sculptor can float forms in space.

From antiquity, fountain designers have streamed, spouted, misted, and sprayed water into a multitude of dramatic displays. Recent artists have experimented with water in different physical states: melting, frosting, evaporating, condensing, and steaming.

In addition to water, all manner of other liquids have been incorporated into "fountains": soap, oil, antifreeze, blood, mud, etc., all chosen for their visual, symbolic, and physical characteristics. One of the key physical characteristics is the *viscosity* of the liquid selected by the designer. Viscosity measures the resistance of a liquid to flow—the thicker a liquid the more viscous it is.

OBJECTS AS EVENTS

Indo-European languages distinguish between nouns and verbs, between things and actions. The distinction is so fundamental that reality itself is split into things and actions, into space and time.

The distinction can be blurred when a "thing" is so fleeting or so immaterial that it seems to be an object in name only. A bolt of lightning, for example, seems as much action as thing.

In the language of the Hopi culture of the American Southwest, however, even as substantial an object as a granite boulder is thought of in the same terms as a lightning bolt. Both are expressed as events: it's just that the granite boulder is the much slower of the two. The Hopi do not separate the runner from the running, the lightning from its flashing, or the granite from its slow and eventual erosion.

Many trends in recent sculpture stress temporal aspects to such a degree that it is useful to adopt the Hopi view and regard objects as events

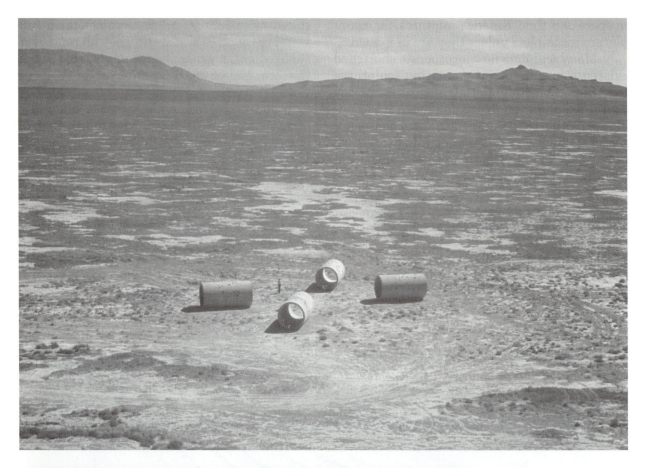

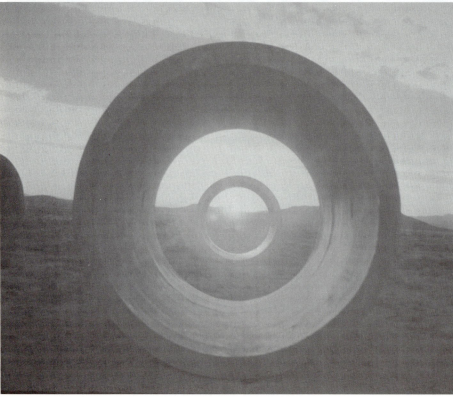

FIGURE 10–12 Nancy Holt, *Sun Tunnel* and *Sun Tunnel (solstice detail),* 1973–1976. Objects may be static, but still incorporate time into their functioning. Sun dials, for example, rely on the movement of the earth to complete their purpose. Similarly, Holt exploits the annual movement of the earth around the sun in this sculpture, which aligns with the sunrise and sunset at the solstices.

The focus is on the viewer who stands at the center of the sculpture, and it is the viewer who is thus aligned with the horizon and the seasons. The detail is a view through the tunnel to the summer solstice sunset on the Utah desert.

Source: Courtesy of Nancy Holt.

The art becomes a record of its own creation and thereby a record of the artist performing the creation. The artist's actions and movements are frozen into the form of the sculpture. Process sculpture gels real actions and *real time* into an object. Traditional sculpture, by contrast, ossified imaginary action from a *mythic* or *historic time* into a sculptural image.

CONCLUSION

In accounting for an object's existence in time, the designer must account for a world that is not just material and three-dimensional, but which is *operant* as well.

An operant world is one in which things happen, in which existence is bound up with action and change. Accounting for an operant reality requires an awareness of the kinetic operations of objects, the waxing and waning processes of people and nature, and the performance of the designer/artist and the user/viewer.

Operant reality supplants static elegance with dynamic richness. It is filled and structured by events that move forward through rhythmic cycles and along sporadic, unpredictable lines. While doing so it weaves space and time into the canvas on which the function and the meanings of art and design take shape.

CHAPTER *11*

Notes on Meaning

INTRODUCTION

Meaning in art is experiential, but meaning is too often confused with explanation. The easier it is to explain the artwork's message, the more meaning it is presumed to possess. The error here is confusing the ease with which an experience can be translated into words with its meaning.

Most visual art, however, is nonverbal. Some artists go to great lengths to remove easily translated messages from their work, and seek instead to convey more ineffable experiences—something words cannot touch. Even art with clear verbal messages attempts to bolster those messages with a strong visual experience.

Object art can be even less dependent on verbal translation than is two-dimensional art. This is because objects possess physical presence. They exist in a spatial context and often demand the behavioral interaction of the viewer.

Function

An object's *meaning* is directly related to its *function,* to those purposes or ends to which the object was created. Objects function in three broad and intertwining categories:

1. *Utilitarian* function: Denotes the physical task that the object was designed to perform and how it carries out the task. This is the primary purpose of the engineer.

2. *Expressive* function: The object will always reflect the thought, values, and feelings of its designer and of the society for which it is created. Expression can be *personal* or *cultural* and is usually both. This is a primary end of objects created by fine artists.

 The functions above were cited in Chapter one. To these a third can be added:

3. *Aesthetic,* (or *formal*) function: Objects can be created and appreciated for their own form and composition, for their character and elegance. The aesthetic is a frequent outcome of good utilitarian and expressive design, but in much art it serves as an end in itself.

Objects that function exclusively in only one of the categories are rare. In nature every object is utilitarian, but aesthetic form of the highest order is common. Artificial or man-made objects always function expressively in some manner despite primary goals of utility or beauty. In a classic automobile, a Rolls-Royce for instance, it is virtually impossible to separate its engineering from its beauty or from its cultural implications as a status object.

INTRINSIC AND EXTRINSIC MEANING

Meaning can be to varying degrees intrinsic or extrinsic. *Intrinsic* meaning refers to those ex-

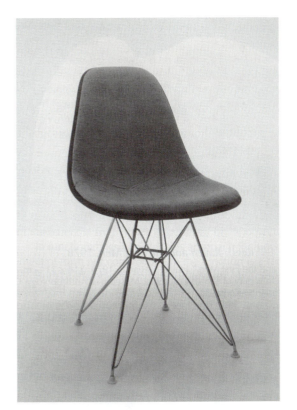

FIGURE 11–1 Charles and Ray Eames, ***Standard Uphol-stered Side, Shell on Chrome Eiffel,*** 1987.

Source: Courtesy of Herman Miller, Inc. Photo by Rooks Photography.

periences of the object derived from its internal relationships, while *extrinsic* meaning refers to those experiences that derive from the object in relationship to the contexts, physical and cultural, in which it is found.

Response to an object is a mixture of intrinsic and extrinsic meanings. Thus admiration for the engineering of a Rolls-Royce automobile is a combination of the precise synchronization (intrinsic meaning) of its mechanical parts and the rarity (extrinsic meaning) of this in the auto industry. Good sculpture often requires the skillful synthesis of strongly realized form (intrinsic meaning) and expressive symbols (extrinsic meaning).

Design through most of this century has stressed intrinsic meanings, resulting in sparse functional elegance. This stylistic tendency, *modernism,* has in the past few decades started to give away to *post-modernism,* which pursues extrinsic meanings by mixing historic styles and cultural symbols.

SIGN AND SYMBOL

A *sign* is any entity that stands in place of another entity. A threatening cloud may drive people inside, not in and of itself, but because of the storm it portends. A statue of a saint, animal tracks, and the roar of a jet are all signs.

Signs are either *natural* or *artificial,* products of nature or products of people. Natural signs are often *indexical,* bearing a physical cause with the signified. Animal tracks and storm clouds are natural signs, while a statue is an artificial sign wholly invented by a person.

FIGURE 11–2 Martin Puryear (American b. 1941), ***Lever 1,*** 1988–89, Red cedar, 429.3 cm x 340.4 cm x 45.7 cm, A. James Speyer Memorial, UNR Industries in honor of James W. Aldorf, Barbara Neff Smith, and Solomon Byron Smith funds, 1989.385 overall.

Source: Photograph by Thomas Cinoman. Photograph © 1999 The Art Institute of Chicago. All Rights Reserved.

Symbolic Analysis

The full appreciation of essentially formalist objects embodies some symbolic experience. So, too, essentially symbolic works may rely heavily on form. This is especially true of narrative artists like Reed and Kolodiejski.

Before his death in 1998, Reed was the most noted contemporary practitioner of First Nations (western Native Canadian) art. The sculpture in Figure 11–3, featured in Chapter 1, is a visual retelling of an ancient creation myth from Reed's Haida culture. To tell this story the artist draws on traditional *symbols* and *stylization*. The image of Raven especially exploits the lozengelike shapes characteristic of First Nations art.

Note how Reed's image of Raven echoes shapes of the masks in Figure 11–4. These depict a version of Raven whose task it is to collect humans to feed a powerful cannibalistic god. Despite the limits of the stylization, the mask maker could still express the fearsomeness of these demigods by *exaggerating* the shapes into beady, piercing eyes and grotesquely elongated and hooked beaks.

In native art of Canada's Pacific Coast and Alaska, this degree of stylization in an image relates the sacredness of that image. For more prosaic entities, the native cultures allowed a greater degree of naturalism, and Reed follows that tradition with more naturalistic representations of the people in the clamshell.

A highly narrative work like Reed's relies on factors *extrinsic* to the work itself: familiarity with the myth and acceptance of the stylistic conventions among them. But as with any good story, intrinsic factors are equally important: how the story is put together and the quality of its execution, for example. Reed's tightly closed spaces in the clamshell, for example, contrast with the open arcs under Raven's wings. Similarly, the smooth architecture of his interpretation of Raven also contrasts with the angular tensions in his struggling humans.

Where Reed honored past symbols and narrative styles, Kolodziejski—in true post-modern fashion—subverts style and narrative structure to plot an equally compelling story. Her narrative takes the form of an elaborate Victorian pitcher in Figure 11–5. A closer, trained look will disclose that the ornate appliques are ceramic casts of early twentieth-century hardware, hardware sold to cheaply replicate pieces of expensive, high-status ornamentation. The irony of Kolodziejski's pitcher is that it recycles these working-class replicas back into high art. There is a self-consciously historic narrative in her use of style.

Such conscious use of style and its residue mark this artist's work as post-modern. In lesser artists, similar concerns might halt at irony and parody. For Kolodziejski, this is just the starting point for a sophisticated commentary of life in general.

Her "story" of an old man swinging, to on the recto and fro on the verso, seems to have no beginning and no end. This frozen image of cyclic motion, however implies freedom, even the necessity, of old age to returning to the unhampered joy of the child. Old age and childhood, the end and the beginning, merge in this exultant narrative.

possible forms and associations an artist can exploit.

Stylization interprets the forms of an image into a purposefully limited range of simple forms, usually geometric. While this range is often predetermined by the artist, it is just as often based on established cultural conventions.

COMMUNICATION

In design and in the other visual arts, many different types of signs and symbols will mix in the same object. No single language of signs limits artistic communication.

Cultural theorist Morse Peckham referred to works of art as "sign packages." In a single art object, he contended, iconic representation may neighbor abstract signs; indexical signs in the form of chisel or brush marks may be juxtaposed with cultural emblems.

Art is as much about how signs are manipulated as about what they signify.

Form, Symbol, and Culture

Forms carry intrinsic meanings that form theorists believe can communicate across cultures. But even the staunchest formalist realizes that the cultural context in which forms are ex-

FIGURE 11–5 Cindy Kolodziejski,
Old Man Swinging, 1998.
Source: Courtesy of Cindy Kolodziejski.

perienced will subtly condition or even radically change the impact of these intrinsic meanings.

Cultural contexts can be defined in terms of the tradition of ideas, values, and beliefs that viewers bring to their reading of form and symbol.

Cultural context may just as well be a factor of the place or environment in which an object is viewed—museums, churches, sports stadiums, etc. The role of place and environment in three-dimensional design is the topic of the following chapter.

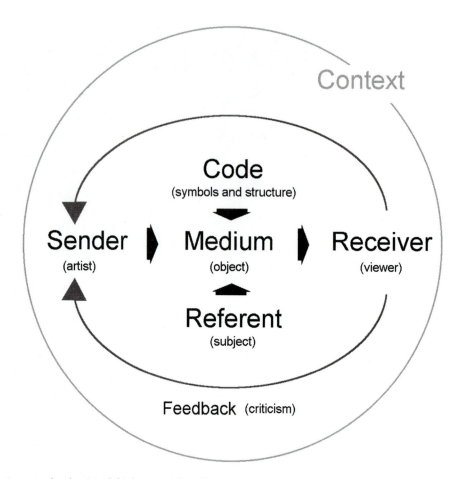

FIGURE 11–6 *Communication Model Diagram.* Like all forms of communication, art and design have certain basic components: Someone sends a message and someone receives it, an object carries the message by encoding a shared set of symbols and by referring to an idea or subject matter. Part of the process is a feedback loop from the receiver to the sender. Based on feedback, the sender will adjust the process to make it more effective. All this is influenced by the context in which the communication is carried out.

The model, although complex, is far simpler than the act itself. In artistic communication each element is in itself highly complex. As a consequence, no single theory adequately explains what art is. Most theories favor one aspect of artistic communication over the others. *Expressionist* theories, for example, concentrate on the artist's ability to transmit emotion, while *realist* theories emphasize the subject of the message. *Formalism* places the essential value of art on the make-up of the object. *Structuralism, semiotics,* and other theories growing out of the study of language look at the role of artistic codes. These theories equate the manipulation of symbols to the grammatical aspects of language. More recent theories focus on the viewer's response and art's social milieu. *Re-*

ception theory values how meaning changes from viewer to viewer and from age to age, and values this over the artist's intention. *Propagandistic* or *didactic* views measure art's efficacy by its ability to direct the viewer's state of mind. Social theories like *feminism* stress the impact of art on a social context and vice-versa. *Deconstructivism* analyzes the social prejudices implicit in artistic codes.

There is an ancient Hindu parable, in which a group of blind sages encounter an elephant. Depending on what part of the elephant he touches, each sage forms separate opinions as to the nature of an elephant. The sage encountering the leg asserts that the elephant is a kind of tree. The sage pressed against the elephant's flank counters that it is more like a wall. Another feels the trunk and proclaims the elephant a relative of the snake. Another realizes the long taper of the tusk and determines that the elephant is a form of lance.

The parable is meant as a lesson on our limitations in comprehending the full complexity of the world. The same lesson could be applied to our attempts to explain artistic communication. Each theory cited above sheds light on only one aspect of the artistic meaning and should be understood as such.

Source: Courtesy of the author.

CHAPTER *12*

Environment and Place

INTRODUCTION

Meaningful objects do more than occupy space. To one extent or another, they interact with the space that contains them, and worm their way into the substance of that space. Whether a gallery, a garden, a public plaza, a temple, or a cave, that space forms the context in which the perceptual, symbolic, or functional goals of objects are realized.

Such a space has, in turn, its own place within a larger cultural or natural context. Like the object, much of whose meaning derives from the space holding it, the space derives much of its meaning from its larger context.

Incongruence

Objects designed for contemplation in a museum, reverence in a church, or enjoyment at home each anticipate very different expectations from their audiences. These expectations conform to the cultural purposes of the particular place they occupy.

Most design works within these expectations, but sometimes artists will *transpose* an object from one place to another. Or similarly they might *juxtapose* two objects from contrasting places. The outcome is *incongruence,* a clash of meanings (imagine a toaster in a church). The results can be ludicrous, comedic, or deeply contradictory in ways that force a questioning of basic perceptions and values. The best such design is usually all three.

THE PEDESTAL

Place any object on a pedestal and it becomes special, somehow more significant. The same thing occurs when a scrap of paper is set in a frame. Both the frame and the pedestal are *cultural cues:* unspoken signals that instruct us to regard the entities they present as separate and more symbolic than the normal run of things. These instructions are known as *tacit conventions* because they are widely adhered to despite the lack of any open acknowledgement.

The pedestal defines a miniature stage, an elevated place removed from normal reality. Here the object acts out its interrelation of form and symbol with the full focus of its audience.

Base and Plinth

Pedestals take two fundamental forms: the base and the plinth.

A *base* joins physically with the object it supports. As the object moves from place to place, the base moves with it. Like a lamp's base, it is part and parcel of the object's design.

The purpose of the base is to make the object at home: first, by providing physical stability and, second, by creating visual and symbolic transition between the ground plane and the object proper.

A *plinth,* on the other hand, is an architectural structure built to hold the object, an element of the site and not the object. While it should suit the visual and symbolic purposes of

FIGURE 12–1 Mark Arctander, ***Ear Rings,***
1996. Contemporary practitioners of *assemblage* (sculpture constructed of preexisting objects) explore the jolt to perception wrought when objects from two diverse contexts unite. Arctander provokes a macabre humor from his surreal juxtaposition of innocent objects: dried pig's ears sold as chew toys for dogs and brass rings. Allusions to the slaughterhouse and the jewelry store give new meaning to the term "earring." Viewers are obliged to construct a new perceptual logic in order to find a place in their minds for this new object.
Source: Courtesy of Mark Arctander.

FIGURE 12–2 Richard Hunt, ***Eagle Columns,***
1998. Hunt came of age as a sculptor in the era of Abstract Expressionism in painting. He became one of a handful of sculptors who succeeded in capturing the dynamism of expression, which hallmarked that movement. Part of Hunt's strategy was to merge his writhing lines with his bases. An architectonic base grants stability to those lines and, at the same time, provide a visual foil, against which his organic movement can be measured. Growth and aspiration seem to burst forth in Hunt's transition from pedestal to sculptural action.
Source: Courtesy of Richard Hunt.

the object, it is nevertheless independent. An object may move from plinth to plinth without sacrificing its integrity.

Plinths can vary from the portable rectangular boxes used in most museums and galleries to elaborate stone mountings found in public parks.

INSTALLATIONS

Pedestals crop out a small piece of a larger space to create a place-within-a-place for the object. Recently, however, many sculptors have eschewed the isolation of the pedestal in order to mount their sculptures physically into the open spaces and boundaries of the exhibit site. Their installed works interact directly with the architectural or landscape space.

Program and Space

The goal of installation art is to join the object and space into one visual statement. This is not really new. Through most of history architects

FIGURE 12–4 Louis T. Rebisso, sculptor, Francis M. Whitehouse, architect, *Ulysses S. Grant Memorial,* 1891. The late nineteenth century saw a spurt of public memorials, especially in Chicago where growth after the famous fire drove civic pride. Common to this genre of sculpture was the creation of a site to set off the sculpted figure. A stroll through Chicago's parks will reveal sculptures set inside memorial plazas, atop man-made knolls, but most frequently on elaborate *plinths.* The Schiller memorial's plinth looks like a small building, evincing its architectural role. The figure of Grant rests on full-fledged architecture—a combination bridge and arcaded pavilion. A stroll under the bridge brings the viewer to a dramatic open glade overlooking a large lagoon.
Source: Courtesy of the author.

FIGURE 12–3 Ernst Bildhauer Rau, *Johann Christoph Friedrich von Schiller,* 1886.
Source: Courtesy of the author.

conceived of sculpture as one with the space it occupied. In much religious architecture, for example, sacred spaces were designed with the sculptural symbolism in mind. Sculptors, in turn, fit their works to the architectural program of the site.

The term *architectural program* refers to the overall symbolic theme that governs the formation of the major blocks of space in the building or site, as well as the detail and elaboration of those spaces. The architectural program determines how the site is to fulfill its cultural function.

What is new about recent *installation art* is the absence of architectural program. Instead, installations are most often transient. At best they exploit the architecture of their temporary housing.

The Modernist Gallery

The nomadic character of installation art is due largely to the impact of modernism, the most influential movement of twentieth-century art and design. Modernism sought to understand art by reducing each mode of artistic expression to its essentials. In the case of architecture, one effect was to pare architecture of its sculptural adornment and leave sculpture to explore its own independence. Consequently, contemporary exhibit spaces are intentionally neutral and denuded of architectural meaning. The gallery is more hotel than home, and installation artists are as travelers unpacking their ideas and transforming the space with their own programs.

Environment

Installation sculpture becomes an *environment* containing its observers. The viewers' point-of-view switches from full round to internal. The viewers movements *through* rather than *around* the space transform the viewers from external observers to inside participants. Such considerations as open and closed space,

FIGURE 12–5 Frances Whitehead, ***Tropism I,*** 1996. Installation art interacts with the architectural space of the gallery, often introducing architectural elements to transform the space. Here Whitehead introduces standard architectural elements: a mirrored column surrounded by floor designs. Whitehead, though, has also created a monumental version of an anamorph. An *anamorph* distorts an image beyond recognition, but allows for a point angle of view that will *restore* the image to its actual form. A viewer strolling around the column soon reaches a point where the swirl of color reflected in the mirror coalesces into the image of a moth. The column transforms into a path of ascendance.
Source: Courtesy of Francis Whitehead.

FIGURE 12–6 *Stonehenge reconstruction.*
Source: Courtesy of the author. Collection of the author.

FIGURE 12–7 *Stonehenge, winter solstice sunset.* One of the oldest forms of ritual space is the circle. As the reconstruction published in 1810 illustrates, Stonehenge is organized in a series of concentric rings (outside of the stone rings is an even broader earthen ring). Best known of the 5,000-year-old Megalithic rings that dot the British Isles and Western Europe, Stonehenge dominates the landscape from a slight rise in England's Salisbury Plain. A ring of hills and low ridges surround this rise and play host to numerous burial mounds, some up to two miles away. Stonehenge's builders augmented its ceremonial status by designing it in accord with a number of astronomical alignments. Directed precisely toward the summer solstice sunrise and arguably incorporating major lunar alignments, the stones record the *cosmology,* i.e., the conception of the universe, held by Megalithic cultures.
Source: Courtesy of the author.

mass and void now transmit as much through bodily experience as through visual observation.

ARCHETYPES OF PLACE

The social spaces, or places, of a culture regularly fall into *archetypes,* fundamental patterns that govern the culture's perceptions of time and space. The three most common archetypes are the *circle,* the *grid,* and the *node.*

Transforming a space from site to place weaves that space into a fabric of social and cultural values that often echoes a people's concepts of space and time as a whole—their ideas of the universe itself.

The Circle

The circle defines a closed, uniformly bounded space. It prescribes a universe whose center is the group and whose perimeter is the horizon, which everywhere surrounds the group and its members. As the group moves, so does its universe.

Tribal and ancient peoples viewed proof of this archetype in the motion of heavenly bodies wheeling around them. This motion sets time on a circular path as well. Time in this circular conception of space is cyclical.

A circular place lends itself to a centralized unity in forming a group and to simple organizations. Its three-dimensional rendition is the *dome.*

The Grid

The grid dices space into rectangular cells: urban lots and hotel rooms are among its manifestations. The grid arbitrarily divides space into manageable components for sale or rent. It provides the compartments, through which to

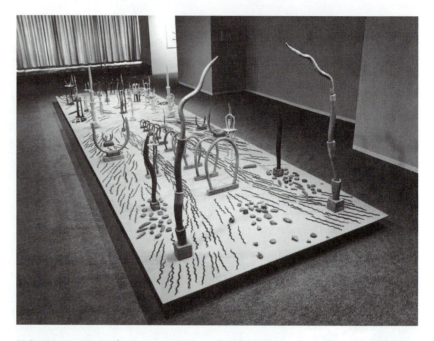

FIGURE 12–10 *Aboriginal "Maps."* Landscape paintings by native Australian artists read more like maps than pictures. Highly stylized and abstracted, these images depict personal interpretations of rituals or of events in Dreamtime—an eternal, sacred realm believed to parallel our own reality. The ritual and cosmological space of these cultures comprises webs of linear energy and actual paths uniting significant points, or *nodes,* on these lines. The upper diagram is of a ritual trail leading to a cluster of connecting waterholes; the lower likely illustrates trails, lined with warriors, leading to a ceremonial site.
Source: Photo courtesy of the author.

FIGURE 12–11 Linda Kramer, ***Current Energy,*** 1982. In this installation, Kramer arrayed totemic markers and alignments of ceramic rods to create a dynamic field of sculptural forms. These delineate a space akin in spirit to the Aboriginal archetype.
Source: Linda Kramer, "Current Energy," 1982. Ceramic, plywood base 28' x 8' x 6' h. Columbia College. Courtesy of Linda Kramer.

Convention is simply a cultural agreement that an existing site may take on a function or meaning distinguishing it from other sites. Many of the world's most sacred sites are landscape features that have garnered their significance in this way

Marking entails the creation of an artificial structure to establish a site as significant. This was possibly the oldest purpose of sculpture: to mark the physical and ideological presence of a place.

Where sculpture marks, architecture *demarcates.* Sculpture centers, architecture en-

closes. By demarcating the peripheries of place, architecture establishes a space to contain activities of social significance. Throughout most of history, sculpture marked significant loci in those spaces set off by architecture, and was thus essential to the architectural program.

BEHAVIOR AND PLACE

A place is a container for human behavior and by no means a passive container. Its physical layout, its symbolic program, and its social function

all act in consort to effect and affect behavior. The archetypes of place, for example, enable sharply contrasting modes of cultural interaction, and consequently aid in determining the desired behavior of a society.

Plan

Due to gravity we move primarily on a horizontal plane. The horizontal layout, or *plan,* of a place is key to its spatial organization. A plan maps the viewers' movements and sequences their points of view. This plotting of viewers' perceptions imparts a temporal, almost narrative, dimension to the experience of place.

Elevation

The vertical layout or *elevation* of a place can be equally symbolic. Like the plan of a place, elevation also imparts a temporal component onto the viewer's experience. Each level can denote a symbolic progression. Climbing higher and higher and looking out over an increasingly vast space can innately convey some of the exhilaration of lordship.

Entering

Upon entering a place, the set of behaviors, attitudes, and perceptions appropriate on the outside of its boundaries are sloughed off and

FIGURE 12–12 E. C. Krupp, ***Painted Rock.*** Native American cultures commonly designated landscape features as sacred, especially if they fit into the cultures' myths. Californian native cultures, for example, elected certain caves as creation caves by virtue of their resemblance to the female birth organ. These were the places where the earth gave birth to creation. The sacredness of this site is affirmed by the myriads of rock paintings on its inner walls.

Source: Photo by E. C. Krupp, Griffith Observatory.

FIGURE 12–13 *Egyptian Temple cutaway plan.* This cutaway model of an ancient Egyptian temple is based on the general layout of the temples at Luxor. The layout, about a quarter mile in length, reflects the ancient religion's beliefs in the journey through death to the afterlife. The first major space is an open court. Its huge, bright expanse contrasts markedly with the dark forest of pillars at the center. This hypostyle hall signified the passage through death. Another series of gateways lead to the deepest and holiest chambers where only the highest priest could preside.

Note how the layout of the ritual spaces is strictly symmetric and how this symmetry breaks down into the maze of functional chambers surrounding the holy of holies.
Source: Courtesy of the author.

FIGURE 12–14 E. C. Krupp, *Habib Ri, Tibet.* The designation of sacred mountains has been a common element of many of the world's religions. Height takes on religious significance and such mountains are seen as connections between earth and the heavens. The pictured mountain, where tradition says that Buddha descended to earth, is remarkable in its symmetry and in the natural terraces stratifying its height into multiple levels. Ritual processions of worshippers wend up to higher and more sacred levels. This mountain greatly resembles a *stupa,* a pyramidlike religious structure held sacred in Buddhist societies.
Source: Photo by E. C. Krupp, Griffith Observatory.

FIGURE 12–15 *Temple of Kukulkan, Mayan,* ca. 1000. The Pre-Columbian pyramids of Mexico and Central America supported their societies most sacred temples. The pyramids are architectural images of mountains and, like Habab Ri, rise in a sequence of higher and higher tiers. Both Buddhist and Mayan cosmology saw the universe as structured into higher and lower levels. Physical reality, sensed by humans, occupies only one of these levels.

Two giant snakeheads flank the base of the pyramid's main stairway. At midday of the spring and fall equinoxes the light falling on the edge of the stairway provides an undulating body for the snake. This is the image of the god Kukulkan descending to earth.

Source: Photo by Margaret Lanterman. Courtesy of the author.

another set is adopted within. The entrance portal is the threshold separating the everyday world from the significant space within.

Consequently, the heaviest concentrations of symbols in architecture adorn entrances and prepare the viewer for experiencing the space within. "Reading" these symbols prior to entering "instructs" one to take on the appropriate mindset to receive the meanings held by the place.

PLACE AND RITUAL

Most of the places explored in this chapter reflect, in part, the ideas that their host cultures held about the shape and structure of the universe. The places the cultures created were crafted as images of their cosmos.

Spatial archetypes govern the conception of space from the very small to the astronomic. While most of this chapter covers environmental spaces, the perceptions discussed can also apply to personal space and to images of one's cosmos.

The circle archetype places the perceiver at the center of space and, in many cultures, signifies a unity, of which the surrounding earth and distant sky are parts. Western doctors, who ministered to the Dakota people in the late nineteenth century, reported difficulties in diagnosing illness. Their patients reported symptoms such as, "The birds no longer

FIGURE 12–16 John Francis Bentley, ***Westminster Cathedral,*** front, began 1884. Entry into a place serves to mark the transition from normal space to the more significant space within. In the case of religious places, the entryway is meant to prepare the entrant for passage into a sacred reality. Few passages possess the mix of grandeur and symbolic instruction that elaborate one's entry into Christian cathedrals. This Victorian façade mixes Roman arches, Greek columns, towers and domes of many sizes, patterned brickwork, and mosaics to prepare parishioners for meeting their God.
Source: Courtesy of the author.

sing for me." The native culture, it seems, did not separate the experience of self from the experience of place. The doctors came from a more analytic, subdividing perceptual scheme. Their grid packages space into packets and their science broke the universe into analyzable parts. The self was divided into anterior (front) and posterior (back), superior (top) and inferior (bottom).

Lines and nodes of the native Australians structure a complex, but unified web from which to knit a cosmos. The self unifies with that cosmos by walking among it and experiencing its sacred points.

From the Nuxalk house to the sprawling temples of Ancient Egypt, ritualistic places function as mediating spaces: the special territory where the person and the universe come to terms.

FIGURES 12–17 and 12–18 *Nuxalk house totems,* ca. 1900. In most tribal cultures, one's home was one's church. The family or clan house followed a formal layout and construction imbued with religious import. Native cultures from Canada's Pacific coast and Alaska followed this pattern and also built larger houses for communal ceremony and governance. The houses recorded in these photos are family houses, whose entry is carved through totem poles. Totemic images on the poles recorded the main clan to which the family belonged and carried a kind of genealogy to specify that family's place within the clan. In this culture, a person's place within the social structure was tantamount to a person's place in the universe as well. Entry through the totem pole was an entry to both a physical and a symbolic place.
Source: Courtesy of the Royal British Columbian Museum. PN 10978.

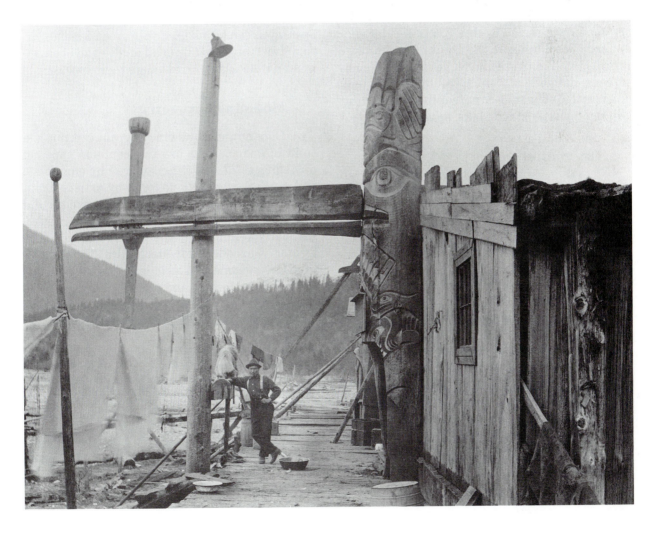

CHAPTER 13

Virtual Space

INTRODUCTION

Digital environments, cyberspace, virtual reality have, by the onset of this century, become commonplace terms in this computer-dependent society. All refer to the ability for computer *interfaces*—monitors, mice, joysticks, touchscreens, helmets, and the like—to convincingly engage the viewer in a perceptual space that can temporarily stand-in for *actual* space.

Interactivity

Virtual space, as this stand-in is known, is an illusionistic space. It is an illusion, however, that permits the viewer to control and modify what is going on inside its perceptual reality. It is this *interactivity* that sets virtual space apart from the illusory worlds of painting, photography, film, and video. Virtual space creates the illusion of a reality that is *operant* and not just visual.

Computer interface devices create this illusion by means of *telepresence*. Originally telepresence denoted the capability of electronically controlling a distant activity based on a video feed. Thus a scientist in a laboratory could steer a research submarine at depths too hazardous for a manned version based on a video camera in its bow. The term now also refers to the capability of controlling activity within video environments in general as with a mouse.

DIGITAL 3D

One great value of virtual space is directly related to its ability to stand in for actuality. Forms and operations can be *modeled* with great detail in virtual space, observed from all angles and even animated if necessary to evaluate their success.

Modeling Geometry

Depending on how a program computes a solid in space, there are two common types of modeling, *solid modeling,* favored by engineers, and *surface modeling,* favored by artists. Solid modeling treats the object as if it were a solid chunk of space, while surface modeling mathematically defines only the object's surface. The former is excellent for mechanical forms built from basic geometric solids, or *primitives;* the latter excels at editing and transforming surfaces into complex curves. Some of the operations that modeling programs can perform are the following:

- *transformation*
 Sophisticated modeling programs can perform most mathematically feasible transformations on primitive solids. Transformations will copy, reproportion, rescale, reposition, or reorient the solid.

- *distortion*
 Distortions effect changes on the shape of a solid that can mimic the applica-

FIGURE 13–1 Stephen Luecking, ***Annulus,*** 1999. One great value of digital space is its ability to offer a preview of an object in actual space, especially one that must perform accurately. This model for a sundial-like sculpture incorporates the rendering abilities of the modeling program to impart qualities of light and material, and that same program's strengths in mathematical calculations. In this screen shot, a spotlight shines along the line of the sun's angle on the first day of winter, so as to test the position of the marker on the left.
Source: Courtesy of the author.

tion of physical force: stretching, compressing, twisting, and the like. *Scalar* distortions will cause one section of a form to change proportion to other sections.

- *Boolean operations*
 If two solids interpenetrate one another, they are in play for Boolean operations. *Union* joins the two solids; *difference* subtracts one solid from the other; intersection saves only the volume shared by both solids.

- *generation*
 All of these programs can generate solids by sweeping a two-dimensional shape along a path in space and capturing the volume defined by the sweep. *Rotation,* or *latheing,* sweeps the form around an axis. *Extrusion* moves it along a line.

- *stitching*
 Surface modelers have the capability of joining (stitching) surfaces edge to edge to create a closed form. This form can then be treated as a solid.

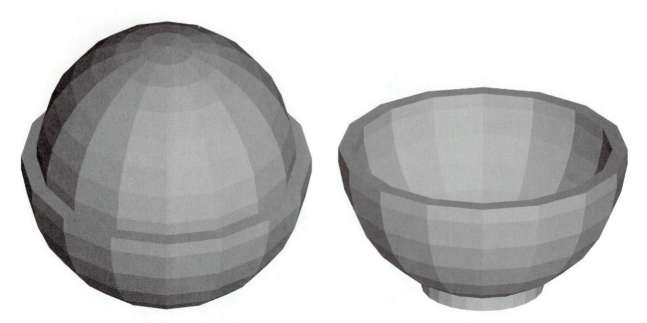

FIGURES 13–2 through 13–6 *Digital Model of a Wooden Bowl with Eggs.* The following group of figures demonstrates a basic modeling exercise, the construction of a simple still life. The bowl begins with the insertion, in **Figure 13–2** (above, left), of two geometric *primitives*—a hemisphere and a somewhat smaller sphere, both sharing a common center. In the next figure, the sphere is subtracted, leaving a hollow hemisphere. Next, a circle is *extruded* into a disk and positioned to become the foot of the bowl (**Figure 13–3,** above right). Applying the *union* operation assures that the two parts become one more complex part.
Source: Courtesy of the author.

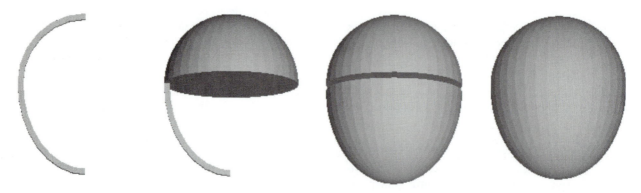

Rotating two adjoining arcs, one elliptical and one circular, generates an egg (**Figure 13–4).** The two domelike halves are then joined into one egg.

CAD–CAM

In the area of CAD *(computer-aided design),* digitally defined three-dimensional space is called *model space.* Its function is to create models for objects that are to be built or to be exported into a three-dimensional graphics program. Conse-

quently, the best CAD programs include drafting components that work in two-dimensional, or *paper space,* to produce working drawings from which the solid prototype can be built.

Such programs also output files to be used in machines that enable the building of prototypes. This integration of design programs with

The egg is copied into the file with the bowl **(Figure 13–4).** The single egg is then transformed into four symmetrically place eggs **(Figure 13–6)** by means of a radial copy command. Up to this point, the objects and the shading were kept at low resolution for faster computing. The surfaces, for example, comprise only a few polygons and appear faceted. Once the final composition is determined, the modeling artist can smooth and refine the shapes by increasing the frequency of these polygons, and by adding texture, color, and lighting to impart greater realism.

Source: Courtesy of the author.

manufacturing processes is called *CAM (computer-aided manufacturing).*

The two basic approaches to CAM are *CNC (computer numerical control),* which uses cutting machines to carve out the form from blocks or sheets of material, and *three-dimensional printing,* which uses a wide variety of methods to deposit material in minute layers. The latter method is the most intricate and precise—it can produce hollow forms with interior details that a CNC machine cannot reach. It is the most favored for rapid-prototyping, where a three-dimensional "printout" is produced directly from the digital model.

3-D Graphics

By contrast the products of three-dimensional graphics are never intended for physical realization. Instead artists construct virtual objects intended for graphic interfaces, such as videos, prints, films, or websites. The actual forms are constructed in model space and then are exported to rendering, multimedia or animation programs.

Often the models are inserted into graphic environments, which appear three dimensional but are actually more like "dioramas" that function as two-dimensional backdrops. Since they are never intended for physical existence, graphic models can, in their design, ignore the laws of physics.

Reverse Engineering

Reverse engineering is the process of copying an actual object into model space. From there it can be manipulated like any other digitally modeled object.

Usually a pointer or a laser traces over the surface of the object recording a "cloud" of points in digital space. From there, a program connects the dots into a web of lines and then into a surface. The most common method among sculptors is a *digitizing arm,* a close kin to the old-fashioned *pantagraph.* In medical

FIGURE 13–7 Elizabeth Schuch, *Leo chair,* 1999. CAD processes are used when the modeled forms are intended for physical realization as *prototypes.* Usually the design takes place with an eye to the final manufacturing process, in which the physical process replicates the digital process used in modeling. In this student sculpture, both the digital and physical object were realized by latheing from a two-dimensional shape. The artist spun highly viscous plaster through a cutout of the sculpture's profile to achieve the final form. From *paper space* a full-scale version of the two-dimensional shape was printed, then sawed out of the template material.
Source: Courtesy of Elizabeth Schuch.

FIGURE 13–8 Fisher Stolz, *Forms,* 1998.
Source: Courtesy of Fisher Stolz.

FIGURE 13–9 Michael Rees, *Ajna Spine Series 222 Amber,* 1998, 20" tall. Both of these sculptures were crafted by *rapid-prototyping* methods. Stolz used laminated object manufacture (LOM) to create his sculpture as a single interconnected form. LOM machines use a laser beam to precisely cut thin sheets of paper. These in turn are stacked and bonded into a three-dimensional form. A hallmark of this process is the singed edge of each paper slice. Rees' more intricate assemblage of skeletal and organic shapes grew from the process of stereo-lithography (SLA).
Source: Courtesy of Michael Rees.

uses, imaging data from CAT scans and MRIs may be used to model portions of anatomy.

VIRTUAL REALITY

Virtual reality differs from virtual space in that it uses *real time* interactivity and an *immersive* interface to create the effect of actually occupying the virtual space. Real time provides the illusion that the participant is affecting the perceptual environment as directly as one would affect the actual environment. There is no perceptible lag between cause and effect.

Immersion

An immersive interface shields the participant from sensing actual reality. He or she experiences—as nearly as is possible—only the sensations provided by the interface. The combination of headsets and digital suits are one common method. These transmit information about the position and movement of the participant, while in turn feeding back to the participant the new audio, sound, and tactile input corresponding to the changing situation of the participant.

A second type of immersive interface is projection-based. The walls of an enclosed space are covered by projections keyed to the position of the participant. In the most immersive of the projection environments, participants wear stereoscopic goggles to enhance three-dimensionality, and a radio transmitter to track their position.

VIRTUAL PLACE

One common metaphor for the internet is *cyberspace*. Cyberspace is full of "sites": There are chat "rooms" to visit as well as "galleries" through which to stroll and "marketplaces" in which to browse. Metaphors of space and place permeate cyber-jargon. All of these metaphors equate the social interactions enabled on the net with the physical places in which these traditionally occur.

When virtual reality integrates with the social interactivity of the internet, there emerges

FIGURE 13–10 *SLA® 7000 (stereo lithography).* In SLA the form grows in a vat of liquid plastic. Laser beams shine into the vat and trace out the object by leaving behind a trail of hardened plastic. Form emerges like a ghost. When the object is complete, the excess liquid is drained. The machine, an SLA 7000 manufactured by 3-D Systems, features a computer on the right and a reservoir of resin on the left. The computer controlled laser beams have hardened enough of the resin to make the form of the car wheel apparent. Such quick prototype manufacture saves industry time and thus money when developing new products.
Source: Courtesy of 3D Systems, Inc.

FIGURE 13–11 Rosalee Wolfe, ***Still Life,*** 1995. Three-dimensional graphic artists seek goals more related to painting than to sculpture. These artists assign objects qualities such as reflectance, transparency, color, and texture, and they frequently render them in a hyper-realistic manner. Rendering such a complex array of reflective and translucent surfaces may require hours of intense computing.

Source: Courtesy of Rosalee Wolfe.

FIGURE 13–12 Minolta Corporation, ***Vivid®.*** This scanner emits a laser from which the machine triangulates closely spaced points on the surface of a 3D object. As the object rotates, the scanner systematically traces it entire surface. Meanwhile, while the scanner's software mathematically records this tracing as a sequence of correctly ordered points. The points can then be connected into a net of triangles, which define a digitized surface equivalent to the original object. Such scanners can determine a point in space to a tolerance of a few thousandths of an inch. Once in the computer, the digitized object can be combined with other digital objects or modified to fit the artist's purposes.

Source: Courtesy of Minolta Corporation, Instrument Systems Division.

FIGURE 13–13 Elumens Corporation, ***cutaway view of Vision Dome®,*** exterior view. *Projection-based* systems for virtual reality surround the viewer with realistic projections. Vision Dome® has its roots in earlier immersive cinema and planetariums where domed screens were used to surround one's field of vision. Now, however, the dome system projects via computer, boasts more sophisticated optics, and allows for interactive features.

Source: Courtesy of Elumens Corporation.

a perceptual reality, in which participants not only interact with the illusion of an operant space, but with one another. When we share the illusion with others it becomes all that more real. Should a sufficiently immersive interface technology couple with the social interactivity of cyberspace, then, some argue, no distinction between illusion and reality will remain.

Base Reality

This is so close to perceiving and operating in the real world that some perceptual theorists use the term *base reality* to denote actuality. Base reality is the physical world that grounds and contains the electronic information, the interface system, which translates it, and the human body, which receives it.

PERCEPTION AND COMMUNICATION

Our perceptual reality can be compared to virtuality. The "interface" of our senses transmits external data (like sound and light waves) to the brain. Culture and learning, constitute a

FIGURE 13–14 Electronic Visualization Laboratory, ***CAVE®.*** An acronym for "CAVE Automatic Virtual Environment," CAVE® provides an even more immersive and participatory environment. Each wall is a rear projection screen whose images are constantly adjusting to the changing perspective of the viewer. The users wear head-mounted trackers that transmit their exact location to a high-end graphics computer. In addition viewers wear glasses whose lenses contain shutters that open and shut 120 times a second, alternating between left and right 60 times. This enables a stereoscopic effect of three-dimensionality.

Source: Courtesy of the Electronic Visualization Laboratory, University of Illinois at Chicago.

"program," which then sorts and interprets this sensory information. Together these translate physical phenomena into the shared, interactive mental image normally called reality. Depending on one's experiences and the communication systems involved, this reality can vary somewhat from person to person and more so from culture to culture.

Reality Models

The brain and senses, then, act in consort to create a mental construct of reality that guides perception and behavior. The importance of that mental construct is brilliantly illustrated in H. G. Wells' short story "Land of the Blind." A pilot crashes in a lost kingdom where everyone is blind and believes that as the only seeing person he will soon dominate the country. He is wrong. The people there have built a perceptual construct, so reliant on blindness and so alien to the pilot, that he can not even survive, much less, dominate.

Reality models, as these perceptual constructs are called, act as both *filters* to screen out useless or unwanted information and *tem-*

plates to impose structure on new information. These two functions are enormously useful to survival, but can also create blocks to learning and communication, especially across cultures whose "filters" and "templates" may not correspond. This is what killed the pilot in the H. G. Well's story.

Artistic communication depends on an understanding of perception, which is an act of communication between our world and us. Art exists, in part, as objects in that world, but also, in part, as objects of mind. As such, these objects can both challenge and assert that relation between the space of the world and the space of the mind.

Good art seems always to question, and change, how we know our world.

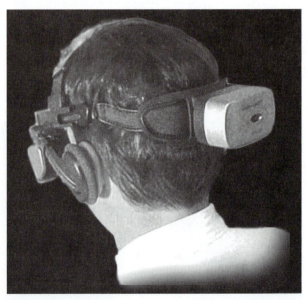

FIGURE 13–16 InterSense, Inc., *InterTrax.* Virtual reality has reached the "at home" user stage. Users can now wear *head-mounted displays and trackers* to interact with a digital environment from a personal computer. Small liquid crystal monitors substitute for lenses in the goggles, with a slight shift between the images in the two monitors producing the stereographic image of a three-dimensional world. Attached earphones carry the audio. Meanwhile the tracker serves as a 3-D mouse to inform the program of the viewer's changing position and direction of view. The program responds by recalculating each new perspective so quickly that the change appears seamless to the user. *Source:* Courtesy of InterSense,.

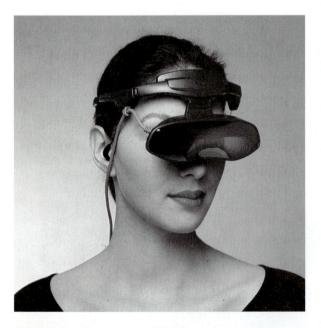

FIGURE 13–15 InterSense, *PC-V®.*
Source: Courtesy of InterSense.

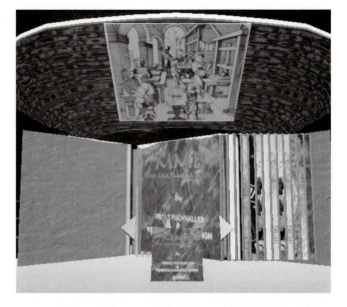

FIGURES 13–17, 13–18 and 13–19 Franz Fischnaller at the Electronic Visualization Laboratory, screenshots from **CAVE® images.** Not even film (and especially not photographs in a book) can capture the experience of virtual reality. However, this sequence of screenshots can suggest something of its nature.

Entering the CAVE® viewers confront a huge book (Figure 13–17). Turning certain pages will reveal portals to other spaces. As one of the first pages is turned, it falls away to reveal a three-dimensional model of Piero Della Francesca's painting, "The Ideal City," hovering in the distance (Figure 13–18).

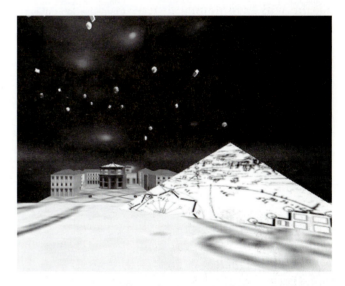

Continuing on, viewers find themselves within the "City" (Figure 13–19) and, like Della Francesca's original painting, it is devoid of people. An animated guide then appears. From this point viewers can elect to travel down certain streets and visit various Renaissance monuments, some of which, in turn, offer portals to yet other spaces.

These Renaissance motifs underscore the similar roles of perspective and virtual reality in their respective eras. Though we know the impact of perspective in profoundly changing humankind's view of science and the world, we have yet to see the corresponding impact of digital replications of reality. It is a safe bet that the impact will be equally profound.

Source: Courtesy of Electronic Visualization Laboratory, University of Illinois at Chicago.

Index